STEP-BY-STEP LIGHTING

FOR STUDIO PORTRAIT PHOTOGRAPHY

Jeff Smith

AMHERST MEDIA, INC. ■ BUFFALO, NY

ABOUT THE AUTHOR

Jeff Smith is a professional photographer and the owner of two very successful studios in central California. His numerous articles have appeared in *Rangefinder, Professional Photographer,* and *Studio Photography and Design* magazines. Jeff has been a featured speaker at the Senior Photographers International Convention, as well as at numerous seminars for professional photographers. He has written seven books, including *Outdoor and Location Portrait Photography; Corrective Lighting, Posing, and Retouching Techniques for Portrait Photographers; Professional Digital Portrait Photography;* and *Success in Portrait Photography* (all from Amherst Media®). His common-sense approach to photography and business makes the information he presents both practical and very easy to understand.

Published by:
Amherst Media, Inc.
P.O. Box 586
Buffalo, N.Y. 14226
Fax: 716-874-4508
www.AmherstMedia.com

Publisher: Craig Alesse
Senior Editor/Production Manager: Michelle Perkins
Assistant Editor: Barbara A. Lynch-Johnt
Editorial Assistance from: Sally Jarzab, John Loder, Carey A. Miller
Business Manager: Adam Richards
Marketing, Sales, and Promotion Manager: Kate Neaverth
Warehouse and Fulfillment Manager: Roger Singo

ISBN-13: 978-1-60895-622-7
Library of Congress Control Number: 2012920990
Printed in The United States of America.
10 9 8 7 6 5 4 3 2 1

Check out Amherst Media's blogs at: http://portrait-photographer.blogspot.com/
http://weddingphotographer-amherstmedia.blogspot.com/

TABLE OF CONTENTS

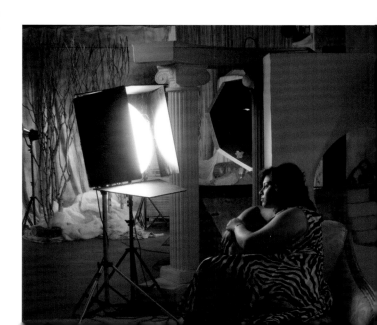

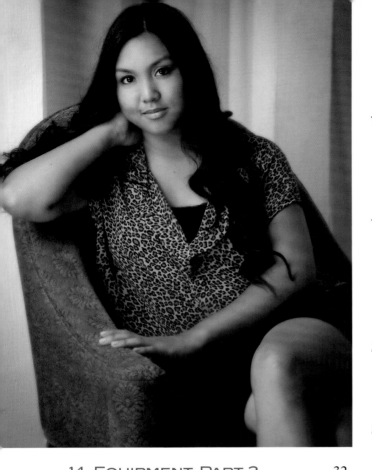

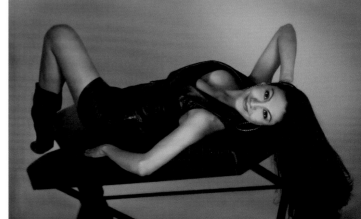

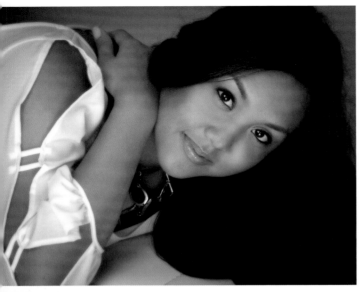

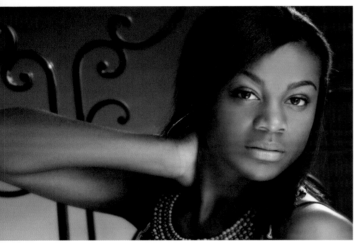

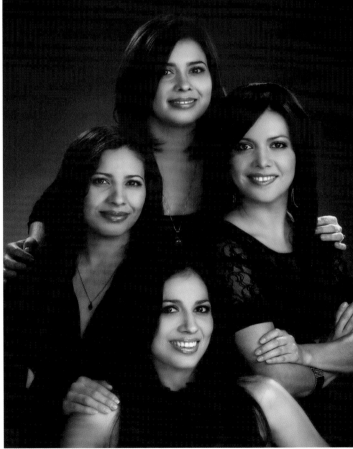

1 EDUCATION AND IDEAS

Big Changes

I have been in this industry for almost 30 years (I got an early start) and more has changed in professional photography in the last 10 years than in the 50 before then. I am not just talking about the way in which we capture and edit our images, but the way in which the average photographer now works with his clients.

Gone are the days when the majority of photographers who read my books had large studios with multiple shooting areas. Today's photographers are more likely to shoot in a modified living room or garage. To these photographers, the profit and stability of working from home are much more important than the prestige of a store-front business.

This book reflects those changes. In addition to studio-type lighting for a devoted, traditional photography studio, you'll find many techniques that can be implemented for studio-quality lighting in home-based studios or on location.

Learn From Pros

Although a great deal has changed in our profession, there are still basic rules that form the foundation for a lasting career.

I believe strongly that the quality of your education will determine the quality of your photography and the longevity of your career. Learning the fundamentals of lighting from a qualified instructor or mentor remains vitally important. Whether through college professors, professional seminars/workshops, or books like this, you need to learn about photography correctly—and preferably from someone who is already a successful professional photographer!

Some photographers skimp on education and hide their shortcomings with Photoshop, but that isn't a sustainable practice. To succeed in this industry, you have to learn and practice the correct way of doing things.

Another issue is that we now see weekly "support groups" popping up, where photographers who know very little can teach the ones that know nothing at all. You have young photographers offering to be mentors to even younger photographers, which is simply crazy. If you take advice from students, you will forever be a student; if you learn from a master, you too can someday become a master. There is an old saying that has never been truer than in photography today: "Never take any advice from anyone who isn't where you want to be."

Unfortunately, this idea of learning photography properly is sometimes regarded as "old school" thinking—the way us "old guys" learned photography. The new way, many photographers claim, is for everyone to help each other.

In my experience, you can only learn to do something properly by practicing how to do it properly. Sadly, I see younger photographers at workshops who are struggling with the frustration and difficulty of trying to break bad habits they learned from other young photographers. Habits acquired based on incorrect information are hard to break; it's much better to train properly in the first place. In fact, I would rather hire a person with absolutely no knowledge of photography and train them to work in the studio than work with someone who has already developed bad habits. It isn't practice that makes perfect, it is *perfect* practice that makes perfect.

THE DESIRE TO LEARN IS COMMON GROUND

The desire to learn and become more proficient as photographers is the common ground on which both newbies and more established photographers can unite. We *all* need to become better—we all need to offer the buying public professional-quality photography. This means we need to get past this "us versus them" mindset that often serves to divide older and younger photographers.

Good ideas are good ideas, whether they come from the younger photographers or the more established ones. In my business, I use all the brains I have and all that I can borrow. Whether an idea comes from the wisdom of the past or the vision of the future, if it helps my business, it's a great idea.

LEARNING LIGHTING 2

For the information in this book to be effective, you must not only *read* it but also *practice* it. Even after years in this profession, I still find time each week to practice my craft and to try new things. Here's what I suggest:

DON'T RELY ON ONE STYLE

Many photographers want to learn one style of lighting that will satisfy all their clients and make every subject look beautiful. While some lighting styles work with a wide range of subjects, nothing is right for *everyone*. In today's marketplace, you must know how to work with many styles of lighting and achieve many looks. This is one way true professionals set themselves apart from mere camera owners. You can't be cheaper, so you must be better!

STUDY PORTRAITS AND LIGHTING

As you go through your life from day to day, look at the effects of lighting on different surfaces. Study the effect of morning light on the bark of a tree, or the midday sun on the ripples of a lake or the face of a child at play. Notice how the light emphasizes or minimizes texture. Notice the effect it has on color. Notice the mood it imparts to the subject.

Likewise, study portraits. Examine the fine detail of the portrait to figure out where the photographer positioned the lighting (look in the eyes). Once you figure out how the portrait was lit, figure out why the photographer made the choices in lighting they did. Only when you figure out *why* can you effectively understand the mind-set and replicate the results.

BUILD ON WHAT YOU KNOW

As you read this book, don't abandon the lighting that you currently use. Many photographers are too quick to give up the lighting they currently use in favor of newer and more exciting ways of lighting a portrait.

One of the things that makes my portraits look like *my* portraits is that I never changed my core style as I learned new ways of doing things. Some of what I do today is based on skills I learned 25 years ago. It worked then and I never found anything better, so I didn't allow the excitement of something new to overwhelm the value of something that worked.

My style of lighting, posing, and composition has certainly evolved, but my style has never changed outright. I like what I like (which is based on what my clients like and buy)—and while I try new things all the time, I use them to elevate my style, not to replace it.

> **SALES SESSION** ▶ We show clients their images a few minutes after the session ends. I do this because I like making money from my images—and a client's excitement (*i.e.*, willingness to buy) is always highest right after the session. In my experience, photographers who learn the proper steps to take to show the client their images right after the session will see 20 to 30 percent increases in the size of their orders.

3 CONCENTRATE, PREVISUALIZE

Calm Your Cluttered Mind

Talk to any successful person and they will tell you their greatest ideas have come to them when they were still and quiet. Great ideas tend to come to us when our minds are clear.

That begs a question: how many great ideas are you going to have if you are filling every second of your life with texting, Facebook, Twitter, video games, and television? Most people have become so accustomed to a high level of stimulation that they don't know what to do with themselves when they don't have at least a phone to keep them entertained.

Photographers pay good money to attend my workshops and seminars, but I always see at least a few sitting in their seats and playing with their phones. How crazy is it to pay good money to learn information that could change your business and your life, then miss out on it because you're so addicted to Pinterest that you just can't focus? How are great ideas supposed to come to you if there is no quiet time? You go from work to family to Facebook.

Before you e-mail me in complete disagreement, put your phone down for one day—take a 24-hour break. During this time, the only thing you can do with your phone is receive phone calls (just in case something important comes up). No texting, no Facebook, no *nothing* (and don't cheat by switching to your laptop). I think it is reasonable to say if you can't go one day without screen time, you might have a problem! By quieting your mind, you poise yourself to discover the greatness that you have within.

Previsualization Is Key

Is a portrait created in the camera or in the mind of the photographer? I believe that portraits should be created in your mind before you ever pick up a camera. Too many photographers— and this goes for both seasoned pros and newbies—rely on the law of averages, taking way too many images in the hopes that something looks good. When a client tells you what they have in mind, you should be able to visualize exactly what your version of that image will look like and

exactly what you'll need to do in order to produce the portrait that both you and the client have in mind.

Visualization is the first step in creating a portrait by *design*, rather than by *default*. This comes back to something I asked you to do in the previous section: look at images that impress you and try to figure out why the photographer made the decisions they did. Once you can figure out not just the *how* but the *why* in the decision-making process, you are on your way to mastery. Anyone can look at the catchlights in a subject's eyes and determine the relative positions of the lights used, but understanding *why* the photographer made those choices with that subject and that pose is the only way to create similar results in your own work.

4 THE BOTTOM LINE

In this book, I will mention money and profit quite often. Quite frankly, I love photography—but I can break even staying home and watching television. I take pictures to earn a living. For most of my readers, this is a profession (or they want it to be), so making money is a necessity. As young photographers, we sometimes feel that photography is so much fun we'd do it for free . . . but then life has an ugly way of teaching us that we (and our families) need money to survive.

There is no "one way" to succeed in this profession. It takes a lot of skill, a lot of luck, a lot of work, and the ability to defy the odds. There are, however, some key factors that will help turn the odds in your favor.

Understand Your Market
In business, what works well in one area doesn't necessarily work in another. There are differences in clients' tastes and beliefs, the population of the

> **DO, NOT TRY** ▶ I have prospered through many recessions and achieved almost everything I have set out to do for one reason: I don't *try*, I *do*. If you say you will *try* to do something, you will almost never succeed; it's a subtle way of convincing yourself that a task is beyond your ability. Instead, set a goal and say, "I will do it." Fully commit to accomplishing the task. If you are only going to *try* to be a successful professional photographer, put this book down and get a job. If you know you *are* going to be a great professional photographer, read on!

city or town, as well as countless other factors to consider. I have tried many ideas during different stages of my business—things that seemed like a great idea when I learned them at a seminar but then flopped when I tried them at home. You can't rely on photographers who know nothing about *your* business or *your* potential clients to guide and direct your studio. Take in new ideas wherever you may find them, but then filter those concepts through your own experience, judgment, and knowledge.

Make Conscious Decisions
Creating a successful business means taking control of every aspect of your work and making conscious decisions based on what you need to do to create salable images. This includes: your choice of equipment; your decisions about lighting, posing, clothing, and background selection; and the decisions you make about your studio's marketing and appearance. If you do this—analyze your unique market and make decisions designed to create the product that's best suited to it—you'll be amazed at the difference it will make, both in your customers' satisfaction and your bottom line.

Develop a Style
Another important profitability factor that might not immediately come to mind is style. With an off-target style, you can struggle for each sale; with a well-conceived one, you can create images that sell themselves.

Many photographers spend their entire careers trying to convince clients to buy images that were created to suit *the photographer's* tastes, not to fulfill the client's expectations. Successful photographers determine what sells, then learn to enjoy and improve on that style of photography.

GET PAST YOUR EGO

Some photographers decide that they can tell clients what is good. This usually lasts right up until the second or third time they are confronted by a client who asks, "What were you *thinking*, taking this portrait this way?" As the client leaves the studio (with their money still in their pocket), it suddenly becomes clear that there is a higher authority.

Creating the kinds of images that sell, the images that clients like, will take some focused practice. I am not saying that you should "sell out" (which is usually what young photographers say when I suggest they learn how to create portraits that clients will actually buy). However, if you want to consider only your own tastes, you should make photography your hobby, not your profession.

5 WHAT CLIENTS WANT

Unless you plan on giving your work away, you have to know what paying clients are looking for in a photograph. Then, you have to be able to create it in the camera. So what do the viewers—and more importantly the *buyers*—of portraits want to see?

BEAUTIFUL EYES

In photography class, we are all taught that the first thing people look at in portraits is the subject's eyes. The eyes are the windows to the soul—but if they aren't lit and posed properly, the windows are closed. Somehow, many photographers forget this important concept, lighting their images to create contour-defining shadows on the face without considering the eyes. Other photographers get so set in their ways that they actually forget to lower or raise the main light to ensure the eyes are lit properly in each pose.

Every light that illuminates a person's face produces reflections (catchlights) in the eyes. These reflections give life to the face. Knowing that the eyes are the most important element in a portrait, I consider the eyes first when lighting a portrait. Some photographers prefer to light the face first—and this is fine, provided you check the eyes and make sure they are also properly lit. (Specific guidelines for lighting the eyes appear in sections 25 and 26.)

SHAPE-DEFINING SHADOWS

Once you have lit the eyes properly, what is the next characteristic that paying clients are looking for? The answer is shadows. We are all taught that light is our photographic paintbrush, but that isn't quite true. Painters and photographers have always struggled to give their canvas a third dimension—a sense of depth. When the illusion of a third dimension is achieved, the artist has taken a flat surface and given it life.

If you study fine paintings or photographs, though, you will notice the illusion of depth is not produced by the *lightest* areas of the portrait but by the darkest. It is *darkness* that draws our eye to the light. It is darkness that gives a lifeless canvas the illusion of depth.

In the left photo, the area of greatest contrast is the face, so it is the first place your eyes land. In the right image, the black shirt is the area of greatest contrast and steals attention from the subject's face.

We've all seen photographs taken by mall photographers or national photo companies. What is the one element missing from most of their portraits? They tend to look flat—lacking a third dimension—because there is very little shadowing. Controlling shadows is difficult for the inexperienced photographers who tend to staff these studios, so most companies reduce the lighting ratio to provide little or no shadowing.

AN EMPHASIS ON THE FACE

Another common misconception is that our eyes are drawn to the lightest area of a portrait first. In fact, our eyes are drawn to contrast, not light. To illustrate this point, look at the two images above, taken against a white background. In the first photograph, everything (including the young lady's hair) is white or near white; her tan skin then becomes the darkest area in the portrait, and that's where your eye is drawn to first. In the second photo, the same subject has a black shirt on. In this sea of white, the black shirt becomes the darkest area in the photograph—and that's where your eye is drawn.

Now, knowing that our eyes are drawn to contrast, where should the area of highest contrast

be? Where do you want the viewer of an image to look first? The answer is the face.

Whether the portrait is head-and-shoulders, three-quarter-length, or full-length, the face should be the focal point. Because the eye is drawn to contrast, this means that the face should be either the lightest or the darkest area in the photograph.

This is so important that it bears repeating: no matter what your portrait style is, you have to direct the viewer's attention to the subject's face. Everything in a portrait should be selected to help achieve that end—and this includes the lighting and shadowing, the clothing, the posing, and the background.

Understanding contrast can also help you to emphasize assets and conceal problems. If your portrait subject has figure concerns you know they won't want to see in the final portraits, reducing the contrast on the problem area will help to conceal it. Knowing this, you can begin to create portraits that direct the viewers' attention where you want it and keep them from noticing what you don't want them to see. This gives you total control over your images.

▼ FOR FURTHER STUDY

From tight head-and-shoulders images, to three-quarter-length shots, to full-length portraits, keeping the emphasis on the face is a key factor in designing portraits that will sell. This requires attention to every aspect of the image from posing and lighting to background and clothing selection.

PICK THE RIGHT STYLE

Learning lighting requires understanding not just how to *produce* different styles of lighting but also how to *use* each style of lighting. Portraits need to make sense visually, and this means that the lighting needs to coordinate with everything else in the frame to produce a cohesive look and style.

Every lighting style you learn (or already know) will have situations for which it's perfect and situations for which it's completely wrong. As the photographer, you have to know how to choose the right style of lighting to produce the result the client desires. You must understand how different styles of lighting affect the look of the final portrait.

CONSIDER THE SUBJECT

Sometimes, the essence of the subject will tip you off to a good choice. For example, if an elderly lady comes in to take a portrait for her children, the scenario immediately rules out some lighting styles. Fashion lighting (like butterfly lighting or ring lighting) wouldn't make a lot of sense. Likewise, classic Hollywood glamour lighting, lighting that would bring out every wrinkle in this lovely woman's face, would also be a poor choice. Chances are something soft and more traditional will better fit the bill.

Conversely, imagine that your client is an aspiring model who wants to take head shots for her portfolio—and maybe a few for her boyfriend. In this case, it's traditional portrait lighting that would look out of place; you don't want

these images to look like senior portraits for her grandmother's mantelpiece.

Consider the Purpose

Just evaluating the subject is not enough, of course. You will need to identify the reason the client wants the portrait taken.

Imagine, again, that a young woman comes to your studio for a session. This time, all you know is she wants a portrait of herself. Unless you ask about the purpose of the portrait, you'll be shooting in the dark. She might want a business portrait, a portrait for her boyfriend, or an image for her grandparents.

Even when the client defines the purpose of the portrait, you should ensure you're both on the same page. Let's consider another example: A woman calls you on the phone and says she wants to have a "sexy" portrait taken for her husband for their tenth anniversary. Now, I want you to envision what poses, clothing (or lack of it), lighting options, and backgrounds you would use to photograph this woman. Do you have the images in your mind? Good. Now, when she gets to the studio, you find out her husband is a minister. Are any of the images you previsualized appropriate for Pastor Bob? Adjectives like sexy, happy, natural, and wholesome all represent different things to different people. Before you decide how to depict someone, you had better understand what these things mean to them.

I work with high school seniors and there is a huge diversity in taste between seniors and their parents. There are seniors who want to push fashion and good taste as far as the parents and photographer will allow; other seniors are more conservative than their parents.

Lighting is a key element in creating the right "flavor" for the portrait. Contrast the image above with those on the facing page.

The key is to understand what your client wants *before* you try to give it to them—and make sure the looks you create are appropriate for the use and tastes of your client. A portrait for a parent should be much different than a portrait for a husband or boyfriend. A business portrait should be taken with a different look than a portrait showing the person in her "off-duty" hours.

PRACTICE

Don't Practice on Clients

The key to studio lighting is to test your lighting setups and to practice using new ones. This should be done on your own time—not during paying sessions—and with friends, family, or other people who agree to pose for test sessions. When clients give you money to create portraits for them, they have a right to expect that you already know what you're doing; they're not paying for you to practice on them.

Practice with Real People

To get the most from your test sessions, photograph people who look like your paying clients, not like models.

One reason many young photographers become frustrated with studio lighting is that they practice only on perfect people. During these sessions, they produce decent images—but, to be quite honest, a first-year photography student can produce good portraits of perfect people.

Here's the problem: one of these photographers shows his perfect-subject images to friends who, naturally, make comments about how talented he is. The feedback encourages him to start working with clients and charging for their services. Unfortunately, his first client doesn't look like a model—she is an overweight housewife who wants a sexy picture for her husband. Completely untrained and completely unready for a session like this, the young photographer blows it. Not surprisingly, the setups that worked so well with a skinny model make the real woman look heavy and ridiculous.

Instead of accepting responsibility for the poor outcome, the photographer blames the woman for being overweight. When he talks to his photo buddies, he makes comments like, "I'm a photographer, not a plastic surgeon—what did she expect?" With that, the circle of unhappy photography customers grows. And that's not just a problem for the photographer who initially failed his subject, it undermines client confidence in our entire profession.

Most portrait clients aren't size 0 supermodels. To make a living, you need to know how to make everyone look their best.

If you put no effort into your images (right), clients won't love how they look. If you care enough to put in some real effort (above), clients will love the results—and be excited to pay you for them.

Push Yourself

Once you've mastered the fundamentals, use your test sessions to push your lighting skills to the next level. During these sessions, don't do anything that you normally do during your regular sessions. Try different light modifiers, use new poses, go to a new location or paint a background to use, but don't do what you always do. Once we mature as photographers, we often know the basics of what we do so well that we never try to do anything else.

APERTURE, PART 1

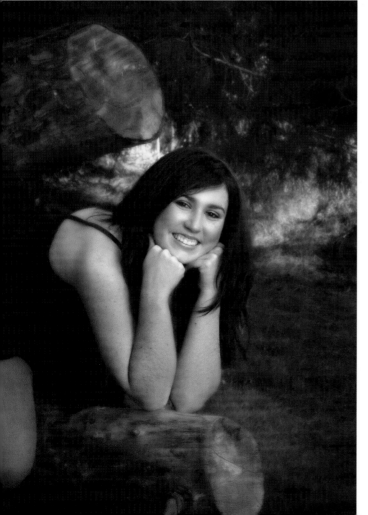

Working on location at midday, I paired diffused lighting with a wide aperture to create a studio-quality portrait.

THERE'S NO MAGICAL SETTING

Understanding camera settings is very important, but they're also completely misunderstood by too many photographers. When photographers ask me about f-stop settings, I find that it's usually not because they want to understand how I created a portrait or why I chose the settings I did. Rather, they are hoping I'll reveal some magical f-stop that will make their portraits look like mine. That doesn't exist. Like every other factor in the portrait design process, the aperture setting is something about which you have to make a conscious choice based on what will be required to produce the image you have previsualized.

DEPTH OF FIELD

The f-stop you choose (plus the lens you choose) does have a huge impact on the final image, but that's because it controls the depth of field.

The current trend in photography is to use very shallow depth of field, created by shooting with a lens set at its widest aperture. As a result, many photographers opt for telephoto lenses with very large apertures (f/1.2, f/1.8, f/2.8, etc.). The combined effect of the longer focal length and very wide aperture is a razor-thin band of focus that draws the viewer's eye exactly where you want it and throws the background

totally out of focus. This is a great thing when, as in the case of photojournalism, you're not in control of the background.

However, this doesn't mean a shallow depth of field should always be used. As with most interesting techniques, it has been overused. Your depth of field (and, thereby, your aperture setting) should be determined by how much of the foreground/background you want in focus—not by the desire to follow a trend.

For example, I often shoot outdoors in the middle of the day (when clients prefer to schedule sessions). At midday, many backgrounds have sunspots or contrasty lighting, so I tend to shoot with my 70–200mm f/2.8 lens wide open, blurring the background as much as possible. Even street scenes can become salable portraits when the elements in the background and foreground are sufficiently diffused.

However, there are many times when the background or foreground needs some sharpness to enhance the portrait or to reveal whatever story you are telling. At these times, you need to stop down the lens to bring the needed background/foreground elements into focus.

In a studio situation, controlling the depth of field is even more important. Painted backgrounds, complex sets, artificial plants, columns, and chairs all need different amounts of softness/clarity to look believable. I have sets that I shoot at f/8 because they add to the overall feeling of the images. Conversely, I have backgrounds (ones I painted myself) that really look hideous unless they are shot at f/2.8 or maybe f/4. As the professional photographer, you are in charge of deciding on the correct area of focus and then setting your f-stop accordingly.

THERE'S NO SINGLE SOLUTION

For years, studio photographers would leave their f-stops at one setting for the entire session. While this simplified the process, it also produced images that were taken for simplicity rather than for the best-possible results.

Again, portraits must be created in the mind before the camera is picked up. You have to look at the scene where the subject is going to be placed, determine how it should be lit, and then decide how much clarity the foreground/background should have. Only then can you select the right lens and aperture combination.

One of the nice things about portraiture is that you have complete control over your images. Contrast this with the challenge of shooting candid events (like weddings or sporting events) where time is always limited and moments are fleeting. As a portrait photographer, you can fully realize your creative vision—and you'd be crazy not to exploit every control to its fullest!

Sometimes, a narrower aperture is needed to keep critical foreground/background elements in focus.

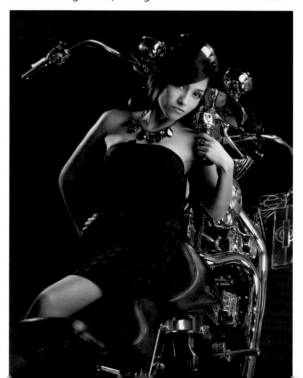

9 APERTURE, PART 2

epth of field (especially in partnership with lighting) can also be used to control where the viewer's eye falls on the subject. By softening the areas you don't want to see, you'll direct the viewer to what is truly important.

In most cases, the critical focus will be on the face, and specifically the eyes—but sometimes another part of the body is just as important. Again, it depends on the purpose of the portrait and the taste of the client.

For example, some clients consider a new tattoo a great reason to have a portrait made—in which case, you'd better showcase their new body art. In boudoir photography, the client might want to emphasize her bust (keep it in focus and well lit) or downplay her thighs (let them fall out of focus and into shadow). As the photographer, you can make this all happen.

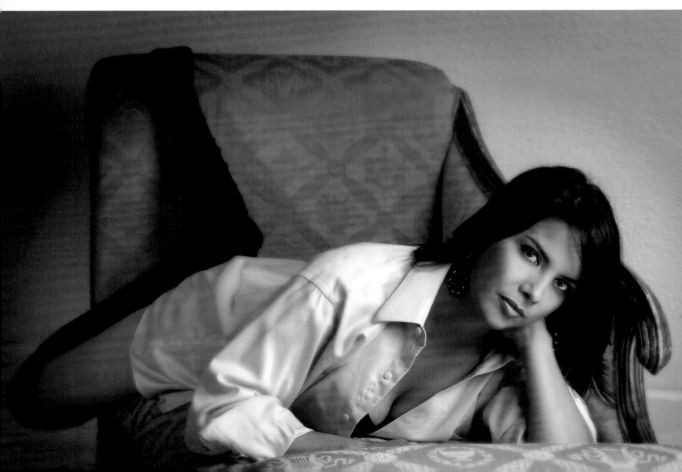

Studio Flash Only

As we talk about purely studio flash, the camera control we will talk the least about is shutter speed. When using only instantaneous light sources, the only real concern about shutter speed is that it not exceed the camera's maximum flash sync speed; doing so would result in incompletely exposed frames. The incredibly fast burst of flash from the strobe will freeze any minor subject movement, so that's not a problem we need to address with shutter speed in this shooting environment. Ultimately, in a pure strobe lighting setup, the shutter speed has very little impact on the final images.

Studio Flash Plus Continuous Lighting

When you add any continuous light source to your setup (window light, room lights, studio hot lights, etc.), the shutter speed becomes an important control over how that light will register and for controlling camera/subject movement. To still subject movement, I suggest setting the shutter speed to a minimum of $1/125$ second. Even at this speed, hand-holding your camera with a longer lens can be a problem, so opt for a tripod if possible.

Studio Flash Plus Reflector Fill

Even in a dark studio, the shutter speed setting will be important when using flash with a reflector for a fill source. Years ago, I attended a workshop at which the photographers talked about using slower shutter speeds with reflector fill. To me, it didn't make sense, given how fast light travels. However, between the shot taken at $1/125$ second and the same shot taken at $1/40$ second, the difference in the quality of light from the reflector was significant. He explained the slower shutter speed gave the bounced light time to fully illuminate the shadow. It worked—and, ever since, I have opted to use a slower shutter speed for portraits in my studios (which have no windows and are painted black).

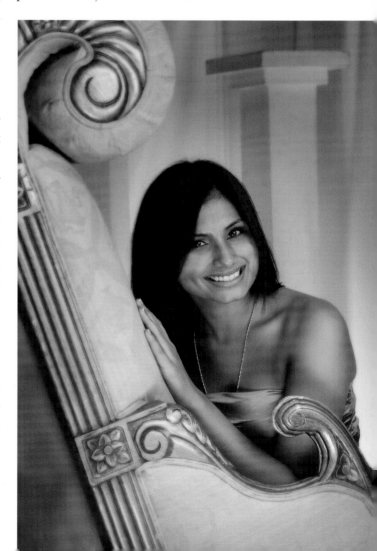

WHITE BALANCE

AUTOMATIC VS. CUSTOM WHITE BALANCE

The quality of the automatic white balance function on today's cameras has led many photographers to give up this important step in studio lighting. To me, the questionable color fidelity and lack of consistency you get when pairing automatic white balance with flash—especially when using brighter colors in the background—rules it out for professional photographers.

In a studio situation, it is always best to do a custom white-balance reading based on your lighting. If you don't know how to do this for your brand of camera, it's time to dig out the owner's manual.

STANDARDIZE THE MAIN LIGHT

Even with the same brand of lights, you will see subtle variations in the actual color temperature.

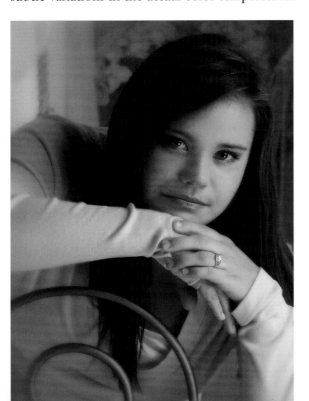

Additionally, the color casts produced by any given flash tube will change as the flash tube ages. This can present a problem if you want to match the light from one shooting area to another in a larger studio—or if you have to regularly set up and tear down your lights to use in a temporary situation.

Fortunately, minor variations in the flash color output really only matter for the lights that illuminate the subject's skin. If a background, hair, or accent light is slightly warmer or cooler, no one will notice. The skin tone on the face, however, is a little more important.

To ensure a consistent color temperature, I suggest using the same brand, power output, and age of flash tube for each main light at your studio. Mark these lights as main light heads, so you will always use the correct light when you need to set up elsewhere. Once you have created a custom white balance for these lights, you won't have to continually adjust your settings.

I find this is especially important for events like proms, dances, and socials where we can have up to five backgrounds operating at a single event. Since these events use automated printing (every image prints on the same setting), we must have white-balance consistency between each of the backgrounds. Ensuring our main lights all match means that one custom white-balance setting works for *all* the sets. As a result, we have one less step to worry about—and we eliminate a procedure that was sometimes forgotten in the stress of setting up for a large event.

JPEG FILES

In the studio, I shoot JPEGs because we show the client his or her images right after the session is over. For my workflow, shooting RAW files with a 10+ megapixel camera would just be a waste of time and storage space—especially since, for most sessions, we're looking at a final output size under 20x24 inches.

However, shooting JPEGs does offer very little room for error. To ensure consistent images and printable-quality JPEGs, we use a custom white balance setting (see section 11) and work to ensure consistent exposures throughout each session (see sections 32 through 35). The tolerances are a lot like shooting slide film, except that we now have a histogram of the image and a digital display that shows each image while highlighting any overexposed areas. If, even with all these tools at your fingertips, you can't be consistent enough to shoot JPEGs in the studio, you are either lazy or you need to work on your basic shooting skills.

RAW FILES

I do shoot RAW files during outdoor sessions in areas where I have not shot before. This gives me some additional latitude (akin to shooting print film) while I am getting familiar with the settings and the existing-light conditions of a new location. I also shoot RAW files when I am photographing families or groups with smaller facial sizes, or when I am printing out larger wall portraits and need maximum clarity.

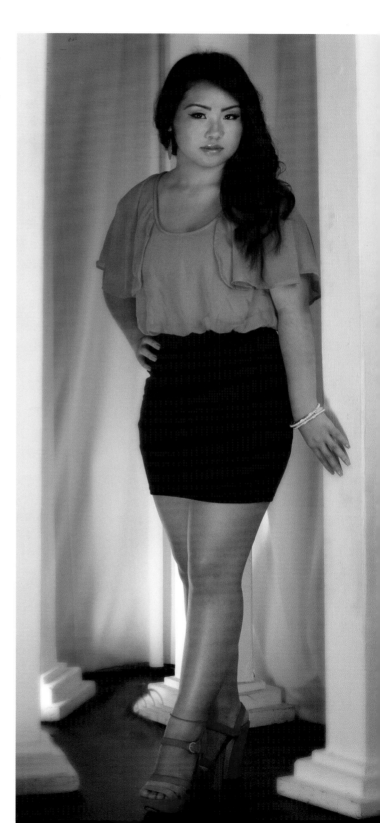

13 EQUIPMENT, PART 1

LIMITLESS OPTIONS

When we used to discuss studio lighting, the equipment was a relatively easy aspect to cover. It came down to the brand of flash and whether you would use individual, self-contained heads (monolights) or a large, power-pack system with multiple heads. Today, it's a different story. Studio photographers now have numerous options—from studio flash systems, to fluorescent and LED units, to hot lights. There's even one guy going around the country speaking about how he uses hand-held shop lights from Home Depot to light his portraits!

AVOID CHEAP PACKAGE DEALS

With the number of new photographers entering the market, and the availability of cheap products from China, there are many companies putting together complete "studio lighting packages." These contain a certain number of inexpensive stands, umbrellas, and lights. These packages

look attractive because of the price, but you will quickly tire of the limited power, the cheap quality, and the inability to purchase standard light modifiers like those we will be discussing.

STUDIO LIGHTS

The type of bulb or flash tube that produces the raw light really doesn't matter. Flash, hot lights, and fluorescent light sources each produce light of a different color temperature, but they are all suitable for studio portraits. The major difference that leads most photographers to eventually settle on studio flash is the amount of light these units produce and the number of attachments that are available for them. Additionally, hot lights produce (as the name suggests) a huge amount of heat. This can make your shooting area very warm and even melt or burn any material or fabric that they are close to.

If you have come up in the wedding industry and are now trying to light portraiture with on-camera flashes, it's time for an upgrade in your gear. Doing weddings, you have time constraints that make it necessary to use equipment you wouldn't normally use as a professional portrait photographer. While flash technology has improved, these small units are still (when compared to studio flashes) very low in power—especially when you add the light modifiers needed to produce professional, studio-quality lighting. You will be much happier and more successful if you make the jump to lighting designed for professional studio portraiture.

EQUIPMENT, PART 2

IF IT WORKS, IT WORKS

When I conduct workshops, young photographers always want to look at the equipment I use. They are often disappointed, however, to see that they already have nicer and newer equipment than I do. They sometimes ask why I use outdated equipment when I could buy any type of equipment I want. Here's what I tell them: What I have does the job.

> **IT'S NOT THE GEAR** ▶ At a workshop I recently led, a wedding photographer commented that you wouldn't want guests showing up at a wedding with better cameras than yours. I laughed and explained that I bet there were high school seniors (my clients) with better cameras than mine—but the *camera* is not important, it's what you *do* with the camera that matters.

If you buy a camera today and it produces the necessary quality for the images you sell to your clients, who says you need to buy a new camera in 2 years, 5 years, or even 10 years? Likewise, if your lights work for what you do, why would you replace them until they break?

Photographers waste *huge* amounts of money buying and trading equipment in the hopes that the gear will somehow make them better. I see

too many photographers who literally don't have a spare dime but are carrying around all the latest cameras, lenses, and lights—and, no doubt, the credit card payments to match!

Don't be led astray when you see speakers and workshop instructors demonstrating all the latest products at their seminars. These photographers are given the equipment in exchange for selling you on the idea that *you too* need the latest version of everything to be a good photographer.

I run a business (and probably you do, too—or at least want to). That means that each piece of equipment I spend my hard-earned money on is an investment. Therefore, I use it until it either wears out or prevents me from offering a product/service that will generate additional income.

If you look at the busiest studios and photography companies, the ones "making bank" in this competitive industry, you will find the most worn-looking equipment you have ever seen. We use it until it is *done*.

INVEST IN KNOWLEDGE, NOT JUST GEAR

Photographers who lack confidence often try to overcompensate through new equipment and big lenses. Don't! Focus that attention and money on your education. What you learn and practice will take you much farther than any piece of equipment you could buy. And once you get to a point where you can buy any equipment you want, you'll find it doesn't matter anymore.

▼ FOR FURTHER STUDY

The idea of getting the most from every dollar you spend on gear doesn't stop with cameras and lighting equipment. You should also be looking for ways to maximize your investment in back-drops and props. If you're creative with set design and light-ing, you can make one element function in many different ways.

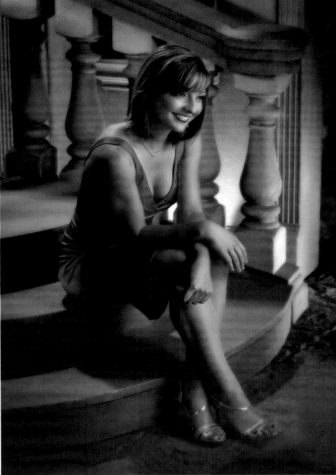

15 MODIFIERS: SIZE AND SHAPE

When most people start into photography, they select their main light modifiers based on what's being used by the instructors and other professional photographers they admire. Typically, they don't question (or really understand) *why* they should use softbox X or octobox Y—they simply assume the pro knows what they're talking about.

The problem with this blind trust is that so many of the high-visibility professionals in our industry are sponsored by lighting companies. Call me a cynic, but I never completely trust someone who stands to make money from me taking their advice. You should decide for yourself the best-possible tool for the job at hand.

Does Size Really Matter?

(Come on—get your mind out of the gutter; I'm a photo guy, not Dr. Ruth! I'm talking about the size and shape of our main light modifiers.)

Distance Relative to the Subject. In general, the larger the light modifier, the softer the light will be. But this, of course, is relative to the distance of the light from the subject. If the distance to the subject remains the same, a 2-foot

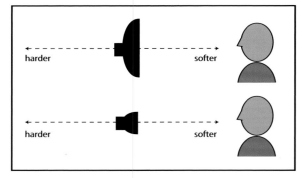

Regardless of the size of the modifier, as the distance between it and the subject grows, the light on the subject becomes progressively harder.

softbox will produce a harder light quality than a 4-foot softbox. If the distance changes, so does the effect of the lighting. For example, if you are working with a 4-foot softbox, placing it 4 feet from the subject will produce softer lighting than placing it 8 feet from the subject. As you move the light closer to the subject, the light becomes larger in relation to the subject and, therefore, softer. This is an important lighting concept to understand.

Control. Next, you have to understand that the larger the light source, the less control you have over where the light will strike the subject. If you deal with perfect people, you want to illuminate them from head to toe. However, in our ever-enlarging society, not too many bodies can stand to be fully illuminated in a portrait. In today's world, you are better off using a smaller light source closer to the subject. This gives you soft light on just the areas of the face and body where you want the viewer's eye to go.

> **WHO'S PAYING?** ► Years ago, I heard a speaker at a convention professing that the only film he would ever shoot was Kodak—he declared that he would never think of changing. Exactly ten months later, I went to another one of his seminars, which came to my city, and he was saying that Fuji film was the best! I guess Kodak didn't sponsor *that* tour!

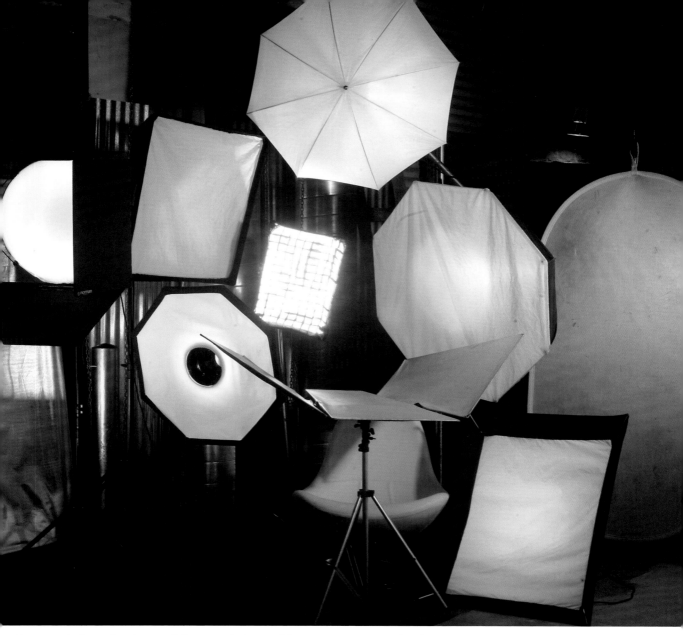

How much does the shape of the main light modifier matter? Not much. These are some of the many light modifiers I use in my day-to-day studio photography.

HOW ABOUT SHAPE?

Shape is irrelevant. I can do anything with a square light modifier that I can do with a round or octagonal one. The only real difference will be the shape of the catchlights in the eyes—and the concerns about this, in my opinion, are based on the opinions of people with way too much time on their hands. Square, rectangular, round, or octagonal—it's really a choice you can make based on what you get used to working with and have on hand. I have them all, and I don't really prefer one over the other.

THE FRONT PANEL

Much more important than the shape of the light box is the type of front panel it has.

Most softboxes have a flat front panel. On some units, that panel is recessed, meaning the front panel isn't flush with the very front edges of the light box but inset 2 to 3 inches. The resulting lip around the perimeter directs the light more efficiently, reducing stray light rays from the sides of the main beam of light.

The second type of front panel is the convex front panel, which curves out past the side walls of the light modifier. The Halo and Starfish series lights are known for this type of front panel.

One isn't better than another; each is suited to a specific purpose. A flat front panel, especially a recessed front panel, gives you more control over your light. The beam of light falls precisely where you place it and falls off (fades in intensity) very quickly so it doesn't spill light anywhere you don't want it. I often use this type of lighting in corrective lighting setups (see sections 47 through 49 for more on this) and take it one step further by adding grids on the recessed softbox to further restrict the spread of light.

A light with a convex front panel, like the Halo or Starfish, produces very broad, soft, and beautiful light—especially when it's feathered (see section 20). If you want lots of gentle light to pour all over your subject, this would be a good type of modifier to choose.

MATCH THE MODIFIER TO THE PORTRAIT STYLE

The lighting style needs to coordinate with everything else in the portrait. Too many photographers use one lighting style (often, the one they learned from the same speaker who suggested their light modifier) for every type of portrait and every type of client.

If your client is a refined lady in an elegant dress photographed against a classic tapestry background and elegant chaise, shouldn't the lighting fit that same style? If your client is a high-class biker chick in a leather jacket, showing 6 inches of cleavage, and thigh-high boots, shouldn't the style of lighting you choose for her be different? Maybe something with a little more contrast or little more of a fashion edge?

A convex front panel (top) and a recessed flat front panel (bottom). This pairing was used to create the image on the facing page.

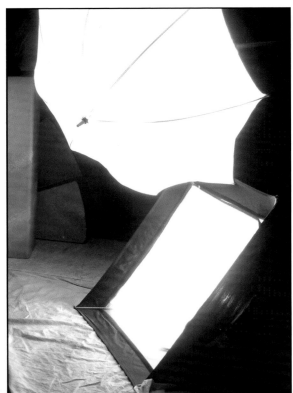

In addition to modifiers that let us diffuse and spread the light, there are many useful modifiers designed to help restrict it. These are very helpful for setups where precision lighting control is needed.

Barn Doors

Barn doors are somewhat expensive, but the control they provide is well worth the cost. Barn doors provide control over the light source both vertically and horizontally. This gives you the ability to turn an otherwise uncontrollable light source into a pin-point light source. There are

times to hunt with a shotgun and times to hunt with a rifle; adding barn doors is like hunting with a sniper rifle.

Grids

Grid attachments also help control the spread of the light. While grids are not adjustable (so they don't give you the flexibility of barn doors), they do eliminate the "skew" rays—rays spreading out from the sides of the light. Another major difference between barn doors and grids is that barn doors don't change the characteristic of the light beam, they just control its size. Grids actually

Adding a grid to the main light reduces "skew" rays.

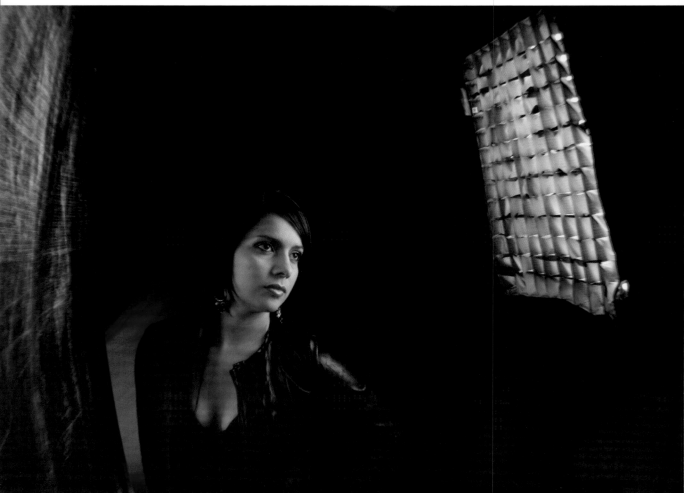

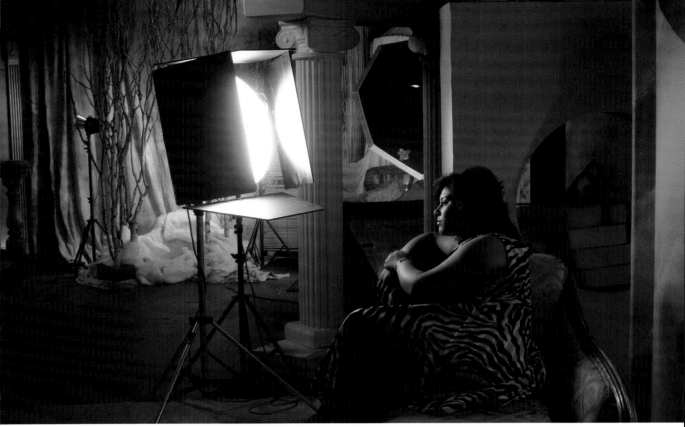

Adding barn doors to the main light reduces the size of the light beam.

change the look of the lighting, making it appear harder and more contrasty.

BLACK PANELS

Black panels, or even a small reflector with a black side, will always come in handy in the studio to use as gobos (devices used to block light from hitting something).

When a light is used in a position where it is turned toward the camera, a large black panel can be placed between the light and the lens to prevent flare. Flare degrades the image quality and color—so if there is any chance direct light will hit the lens, block it with a black panel.

Small black-backed reflectors can be used effectively to hold light off selected areas of the subject (such as a white dress or a bare, fair-skinned shoulder positioned close to the main light). This vignetting effect can be very helpful when using precision lighting.

Both black panels and smaller reflectors can also be used to create shadow wherever it is needed. Think of these modifiers as light sponges. They are perfect for when you want to create a shadow to hide some feature that the subject would rather not see in their final images.

GO BARE ▶ If you are in a studio situation and need a soft light source but have no umbrellas or other modifiers to diffuse the light, you can get soft light from any flash tube by simply leaving the reflector off. Use just the bare bulb.

You might not expect it, but in his classic book *Alice in Wonderland*, Lewis Carroll put forth some important advice for photographers. Here's the exchange I'm talking about:

"Would you tell me, please, which way I ought to go from here?"

"That depends a good deal on where you want to get to," said the Cat.

"I don't much care where—" said Alice.

"Then it doesn't matter which way you go," said the Cat.

The same basic rule applies when selecting the tools you will use to create the portraits you have envisioned: you have to know where you want to go before you decide how to get there.

WHY IT'S CRITICAL

The main light may be the only light in the scene or it may be part of an array of lights. Either way, it is critical to understand how this one light shapes the look of your image—and how it can be modified to create a variety of looks.

When picking a main-light modifier, you need to select the one that is right for your image. This has nothing to do with what I or another photographer might use. It's all about the style of light *you* want to offer *your* client.

HOW TO CHOOSE

Sometimes, lighting choices will be easy; other times, using the type of light required to correct one problem will create another problem. For instance, if your subject has weight issues, you'll want to use a main light that is controllable and produces a strong shadow. If, however, the client also has a larger nose, the additional shadowing from this main light is going to need your attention. You can still use the harder light, but you have to turn the face to have the nose pointed more at the main light, reducing the shadowing on the face.

Choosing a main light source isn't that hard. Just consider each client, look for the areas of their body that they wouldn't want to show, and

then use common sense to select the best main light source to handle the job.

Practical Options

Most portrait photographers must deal with a wide range of session types on any given day. You could go from a child's session, to a boudoir session, and then finish with a family portrait shoot.

While each of these clients might ideally be photographed with a different main-light modifier, this isn't practical for most studios. Most studios select a single multipurpose light box or modifier that will fill most of their needs.

What you choose will depend on the studio size, budget, and method of shooting. I know some photographers who use huge light boxes to photograph children, since they are so active. Families are also well served using a large softbox to provide even illumination from one side of the group to the other. For boudoir, on the other hand, a main light that produces more contrast would be best. The additional shadows are slimming and help bring out the contours of the body.

However, if you switch to a beauty dish or parabolic with barn doors for your boudoir session, you're going to have to rebuild the whole setup if the next session is with a child. Although, I suppose if you have wood floors and a staple gun you could staple the seat of the child's pants to the floor to keep them in place under the parabolic's narrow beam of light. (I'm just kidding— *don't do that!*)

My studio's solution is, in general, to use a variety of sizes of the same light modifiers. My favorite general-purpose main light modifier is the Halo, which is similar to a Larsen Starfish. It has

a silver lining, a very thin front baffle, and I use the light head facing forward rather than bouncing it off the back of the light box. This produces a nice look that has enough contrast for most applications.

This is not to say I use *only* those units. I use many types of light modifiers in my work, but I make the choice to change from one to another very selectively. I know exactly what lighting effect each modifier produces and make my decisions accordingly.

THE MAIN LIGHT: SOFT

Light is called "soft" or "diffuse" when there is a gradual transition from the highlight area of the image to the darkest shadow. In portraiture, soft light can diminish the appearance of harsh lines and wrinkles. It also produces less shine on the subject's face than hard light will (see section 21). The majority of traditional portraits are made with soft light. It is the most flattering light for portraiture and is more forgiving of poorly placed light sources.

BIGGER IS BETTER, RIGHT?

When I was a new photographer, I thought I should use the softest light possible. I was wrong. When it comes to softboxes, bigger doesn't necessarily mean better—even if those large boxes do seem pretty impressive. With a main light source

that is too soft, the light lacks directionality and contrast, and the final image looks flat. It lacks the "pop" that you want in professional images.

Very large boxes *are* great for lighting families or larger groups. They are also a good choice when you need to produce soft light over a large area (for example, when photographing a very mobile young child). However, when I am photographing single subjects, I use a small or medium softbox for full-length poses. This allows me to light only the areas of the subject to which I want to draw the portrait viewer's eye.

If you prefer more traditional lighting and want the lighting characteristics to be consistent in all of your portraits, use a large softbox for your full-lengths, a medium softbox for your three-quarter-lengths, and a small softbox for your head-and-shoulders shots. Why? Well, when you are photographing a full-length shot, your camera-to-subject distance is greater than it is when you are capturing closer shots—and because the softbox needs to be placed farther from the subject, you'll need a bigger light to get that desired soft light effect.

There are many variables that affect the characteristics of the light. Let's take a look at how changing some of the variables will affect the look you're after.

SIZE AND DISTANCE

As discussed in section 15, a larger light source generally provides softer light than a smaller source. However, moving a large source farther

from the subject makes it smaller relative to the subject. Therefore, when a large softbox is used close to the subject, it will emit much softer light than it will when it is moved to 10 feet. If you only have one softbox, changing the light-to-subject distance is just as effective a way to change the look of the light on your subject as swapping in a larger or smaller box.

ORIENTATION OF THE HEAD

There are other ways that you can manipulate your softbox to make its light a little softer or harder. If you are using a softbox with the flash head facing the subject, the light will be harder than it would be if you aimed the flash head at the back of the box (so it bounces off the back of the box before passing through the diffusion panel).

DIFFUSION AND INTERIOR

Directing the light through just a single diffusion panel produces a less diffuse quality of light than you could create by adding the second diffusion panel supplied with most softboxes.

Additionally, with everything else being equal, a softbox with a silver interior will produce light that is harder than a softbox with a white interior.

I like to use a softbox with a silver lining and a thinner front diffusion panel. This fits my style of photography and the tastes of my clients—most of whom are high school seniors and like portraits with more contrast and a higher color saturation.

▼

FOR
FURTHER
STUDY

Creating softly lit
portraits that still
have good texture and
depth requires careful
control of the large
light source.

The Edge of the Light

If the light from your softbox is too hard, you can also create a softer lighting effect by using the light from just the edge of the softbox (rather than the harder, more direct beam of light emitted by the full front panel). This technique is called feathering. I tend to select softboxes that produce more contrast than I typically want, then feather the light to soften it.

Feathering is a useful technique when photographing groups.

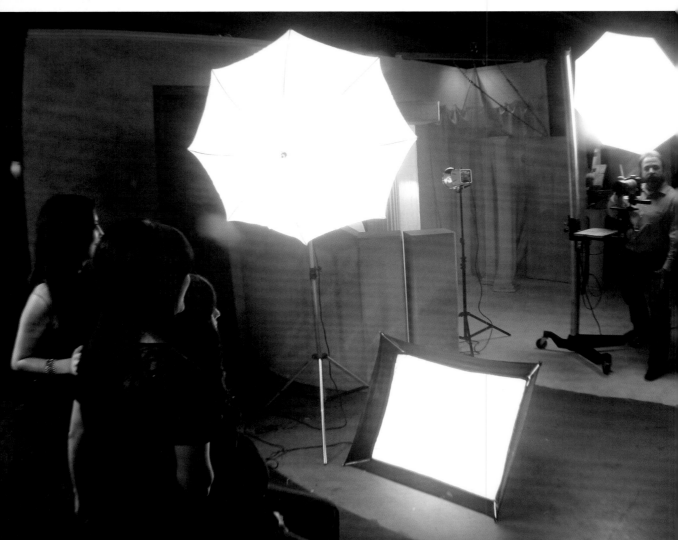

Feathering simply means using the light that comes from the side/edge of a light box, rather than the light that comes squarely from the front of the box. To do this, you basically aim the main beam of light from the light source above or slightly to the side of the subject—not directly at them.

Try It Outdoors

This effect is what makes it possible to use reflectors for outdoor portraits. When I tell photographers I use nothing but reflected sunlight for most of my outdoor photographs they think I am kidding. They say, "That light is too hard!" or, "I tried it and my subject squinted through the entire session." These photographers obviously don't understand feathering. When you aim the intense beam of reflected light *past* the subject's head (above or to the side), the edge of the beam that falls on them provides a soft and beautiful main light source that is always the correct color temperature.

With Group Portraits

Feathering the light is also an excellent way to illuminate a family or large group. When we photograph schools, we often have to use limited equipment to create portraits of huge groups. For these images, we want to have even lighting from left to right and from the front row to the back row.

Believe it or not, you can photograph a hundred students using only two lights. We raise the lights to about 10 feet, then direct the main beam at the back row. This feathers the less intense edge of the beam across the front rows—and by the time the more intense core of the light reach-

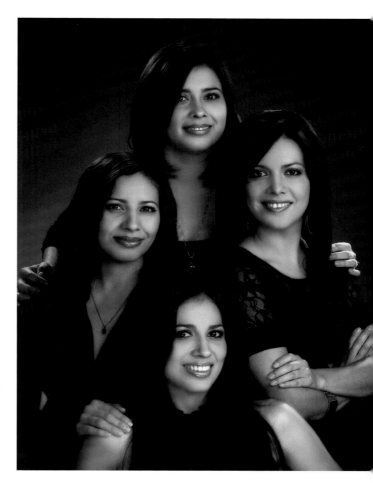

es the more distant back row it has also dropped off in intensity. The result? Even lighting from front to back. To keep it even from side to side, we keep the lights slightly off the center of the group. At this point, both lights would be overlapping, causing the area to be brighter.

You can use the same idea when lighting a group in the studio. Feather the light off the person closest to the main light and have the main beam of the light striking the person farthest from the main light source. With careful light and subject positioning, you should not have to even out the exposure in Photoshop.

THE MAIN LIGHT: HARD

TIMELESS DRAMA

Hard light is characterized by crisp, well-defined shadows and a high level of contrast. There is a quick transition from highlight to shadow. As I mentioned in section 19, soft light is the choice of most portrait photographers. However, hard light—when it is carefully controlled—can be used to create very dramatic and appealing portraits. The classic Hollywood photographers of the 1930s and 1940s used exactly this quality of light to create their timeless black & white portraits.

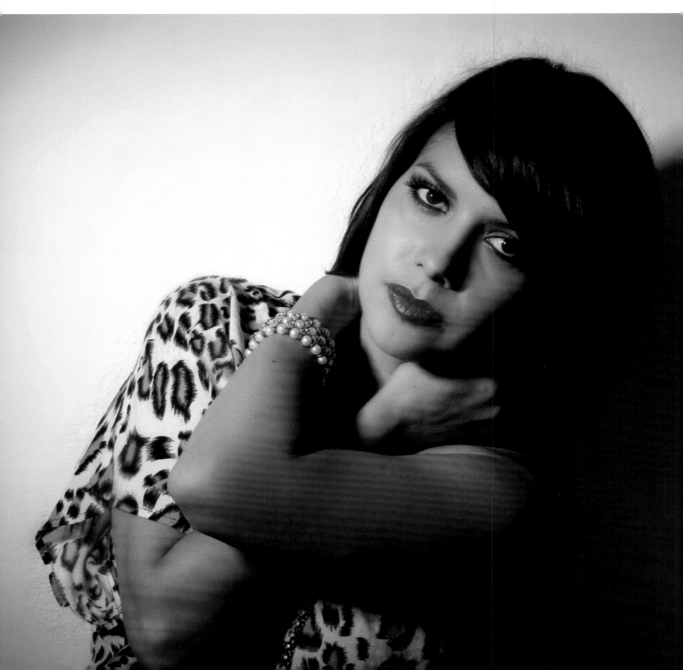

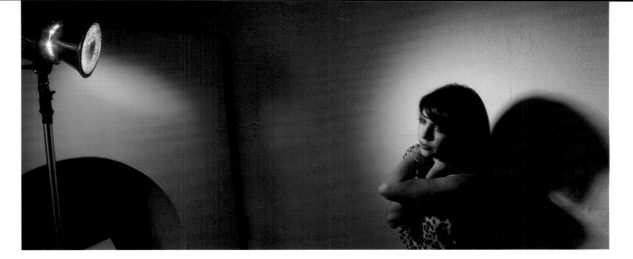

MODIFIER SELECTION

Like modifiers designed to diffuse light, attachments that create harder, more directional light have subtle variations in their design and functionality—but they all produce harder light than a softbox.

A flash unit fitted with a parabolic (metal) reflector is the tool of choice as a main light source for most traditional portraits made with harder lighting. These reflectors come in a variety of shapes and sizes as well as different interior finishes, each of which will affect the light quality.

There are also a great number of accessories that can be attached to the parabolic reflectors to allow enhanced control over the light (snoots, grids, etc.). You can even modify your parabolics by changing the finish of the interior or putting diffusion material over the end of the reflector.

The best part of using a parabolic for your main light is the amount of control it offers. When you can add light precisely where you want it, you can create a dramatic portrait. Turn the page for some additional examples.

▼
FOR FURTHER STUDY

For these glamour portraits, shooting with hard light produced a very dramatic look. They've got an updated style, but the shots still call to mind portraits of classic Hollywood starlets—images that were also created using hard light sources.

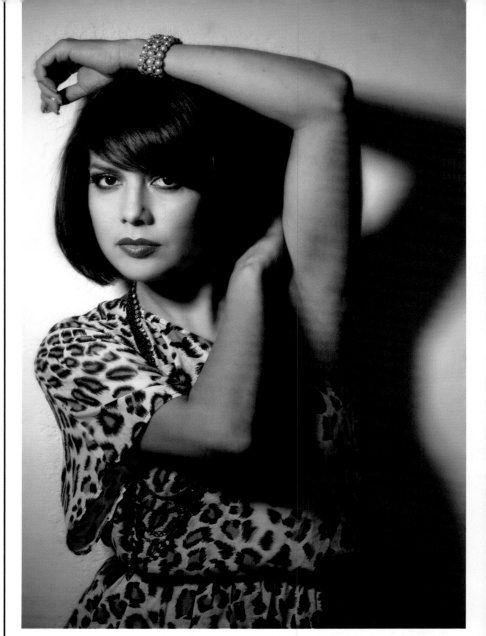

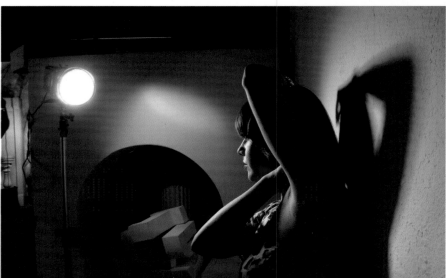

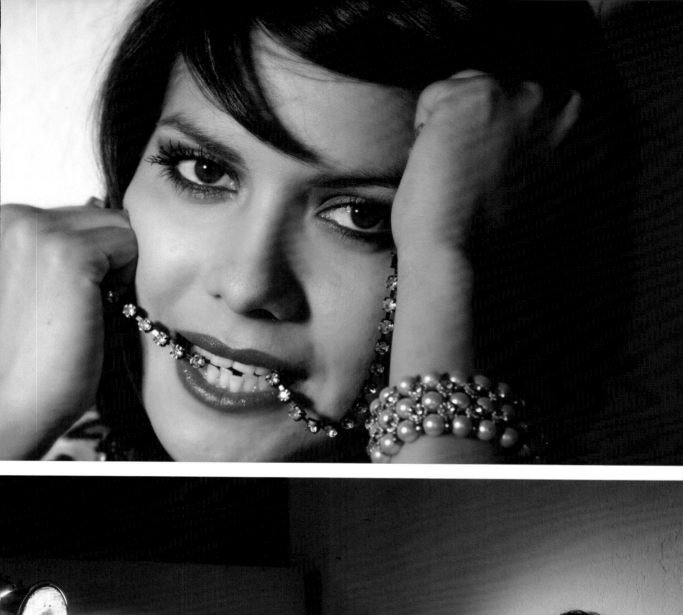
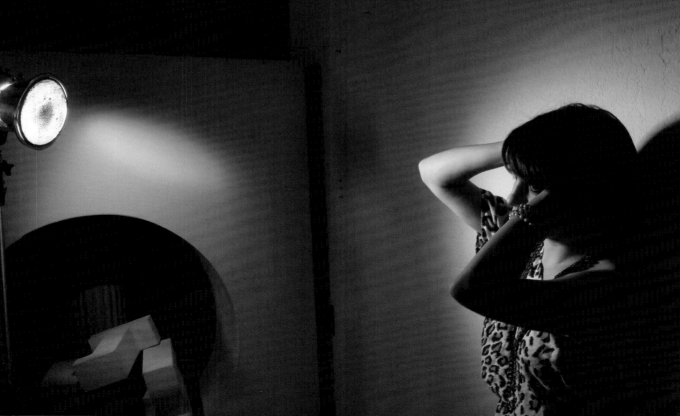

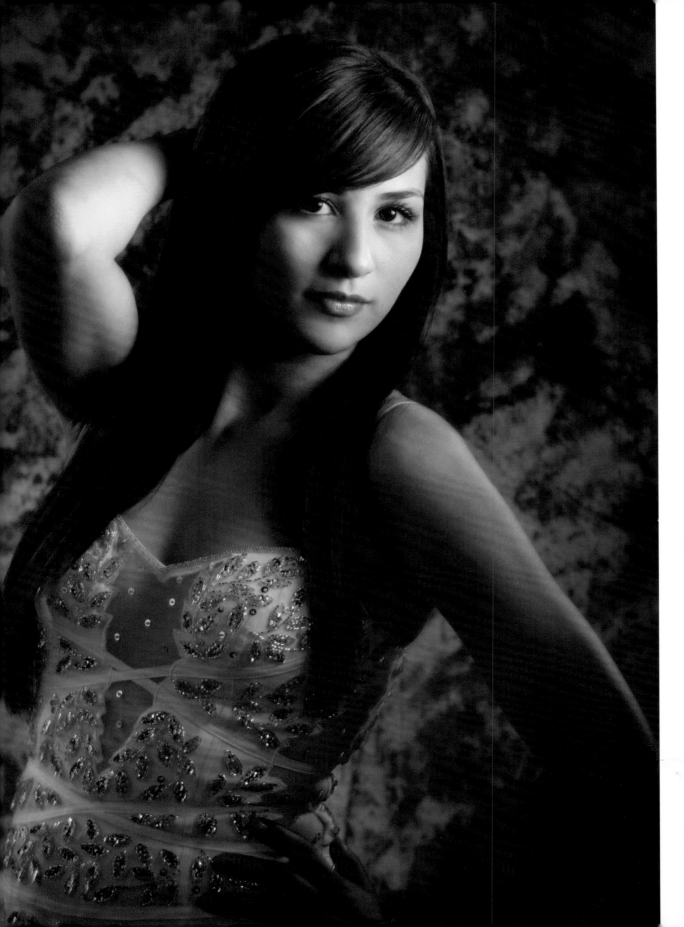

Paired with barn doors, parabolics and beauty dishes are some of my favorite main light sources. The light from these units is very versatile, capable of producing everything from a traditional portrait to an "old Hollywood" look. These lights can basically bridge the gap between the soft light of a softbox and the hard light of a spotlight.

ADD BARN DOORS

To me, barn doors are a must for the type of work I do. I want control over where my main light strikes the subject, something that is especially important in boudoir, fashionable senior sessions, or elegant women's portraits. Being able to keep the light off a pale upper arm, a heavier thigh, or a not-so-flat tummy makes a huge difference in the client's satisfaction with her portraits. Barn doors give you amazing control, while also adding more contrast to the light from the parabolic/beauty dish.

LIGHT PLACEMENT

For a Hollywood look (perfect for boudoir, elegant portraits of women, and fashion images), I

use the beauty dish as a single main light. I also use this light in partnership with an additional floor light for fill (see section 29).

When using a smaller light source like a parabolic or beauty dish, you really must study the eyes when placing the light (for more on this, see section 25). Between the smaller size and the additional contrast, you will find yourself working with the light lower and at less of an angle compared to where you'd place a softbox or Halo.

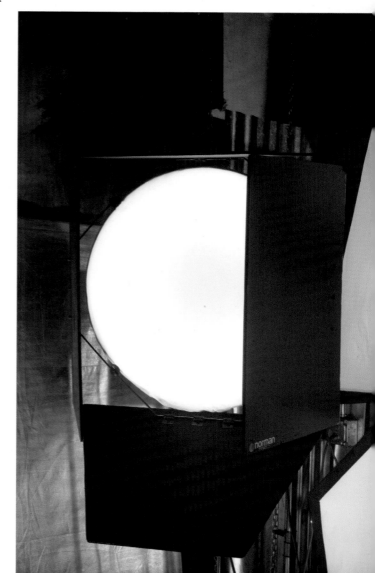

BARN DOORS ▶ I use AlienBees lights. These are great lights for the price—and I receive no money or free lights for saying so. The beauty dish I use is from AlienBees, but they didn't have barn doors for it. So I took a chance and ordered a set of Norman barn doors in the same size—and it worked just fine.

▼ FOR FURTHER STUDY

A parabolic with barn doors (as seen on the facing page) was used to create a wide variety of images during this session. As you can see, even with a simple light and a simple background, there are almost limitless possibilities.

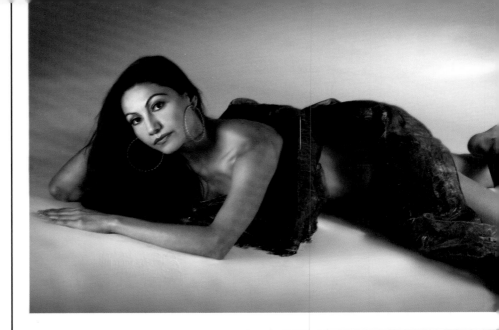

Because hard lights
emit a narrow beam
of light and have
quick falloff, they can
be used to precisely
highlight just one area
of the subject. This not
only helps you empha-
size the intended focal
point, it lets you mini-
mize anything that's
not important (or that
you might want to
conceal).

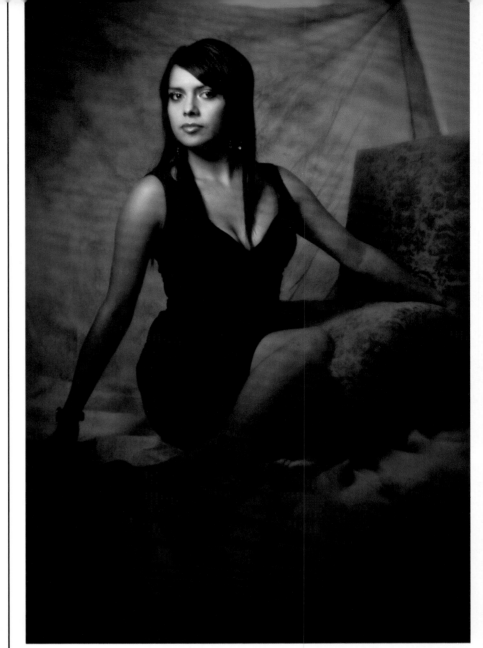

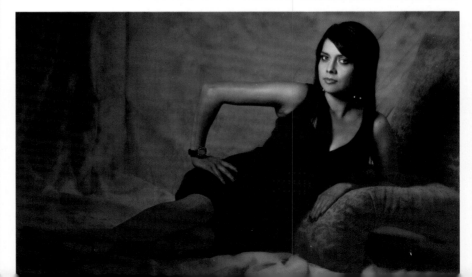

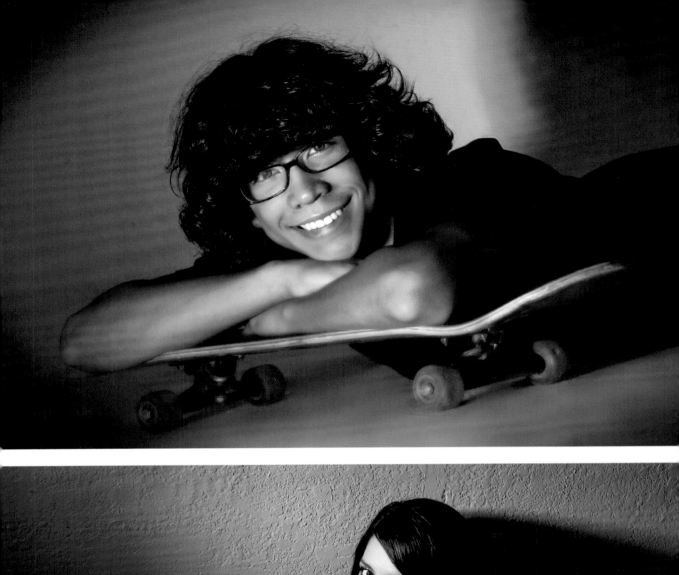
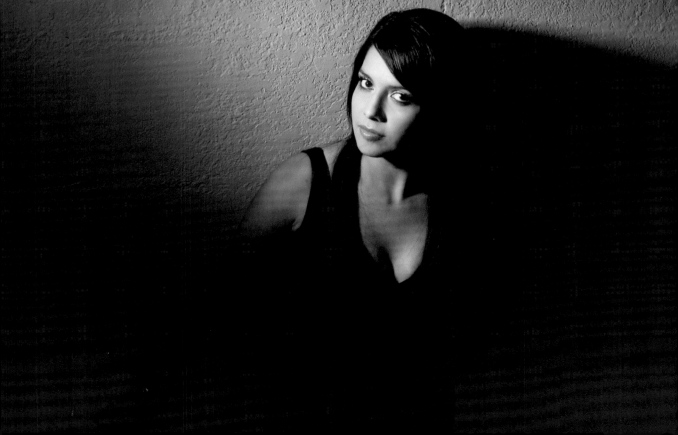

23 RING LIGHT

Most photographers use a softbox or a light fitted with a parabolic as the main light for their studio portraits. I am definitely not knocking the use of a consistent approach. For example, when I am shooting yearbook photos and need consistent results for 700 to 1000 students' images, it does the trick.

The problem is, when the majority of photographers are shooting this way, the majority of the portraits on the market have the same look. I have always been interested in creating as many portrait styles as possible for my clients. Also, when I master one approach, I want to move on to find another great tool or technique.

Fashion and advertising photographers are using a variety of main lights, and we should follow their lead because our clients look to fashion magazines and advertising for their cues about beauty, style, and self-image. When a woman thinks of being photographed, these are the images that have set the standard of beauty and style in her mind.

COST

Ring lights (large versions of the lens-encircling lights used in macro photography) are a common main light source in fashion photography and produce a very smooth, shadowless look.

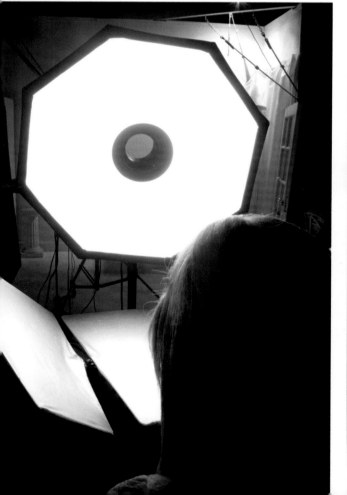

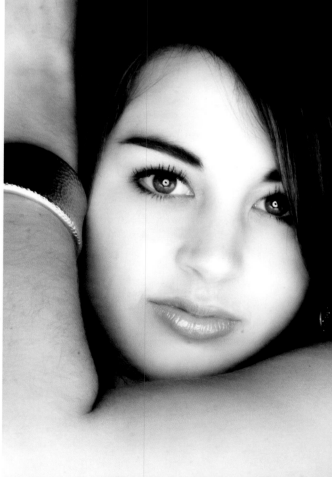

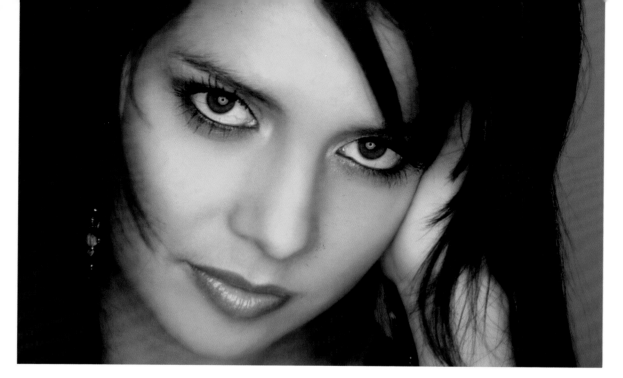

iris (the colored part of the eye). You *definitely* don't want to see them in the whites of the eyes.

If the light makes a ring in the iris, you are probably too close to use a telephoto lens and avoid distortion of the subject's face. If the catchlight looks like a large, solid softbox with no hole in the middle, you have placed the light too far away for its size.

The effect can be beautiful for the right face, but the cost of these units can put them out of reach . . . unless, of course, you use AlienBees. Alien-Bees offers one of the best ring lights I have seen in the lower end of the price spectrum.

WORKING DISTANCE

The hardest part of using a ring light is getting used to the correct working distance for each type of composition. The size of ring light is what will determine this. The light is in the right spot when the catchlights it produces appear in the

PORTRAIT LENGTH

The most impressive part of the light from a ring light is its effect on the eyes. It can look amazing. However, you can't *see* this effect when you use the light for full-length compositions (because the face size is so small). For that reason, I typically use ring lights only for close-ups. It isn't an easy light to work with—so if you aren't going to clearly see the eyes anyway, there are better main light choices for longer portrait compositions.

STRIP LIGHT

I love to use a larger strip light (basically a softbox with a very elongated, rectangular front) as a main light source. Its narrow beam of light is so unique that I find many uses for it. I use strip lights during boudoir sessions, fashion-oriented senior sessions, and even for elegant portraits of women. In addition to its unique look and shadowing, the narrow beam provides an especially flattering main light for women, who are always worried about looking slim.

PLACING THE LIGHT

Since the characteristics of this light are different from a standard square softbox, you will have to test your lighting until you feel comfortable and confident in its placement.

Most of the time, I work with the strip light at about a 70 degree angle to the subject (roughly halfway between 45 and 90 degrees).

Strip light positioned horizontally on the floor.

The height of the light depends on whether I will be using it as the only light source or along with a floor box for fill (see section 29). If the strip light will be used alone, I place it so that the subject's face is basically in the middle of the strip light. I also tip the top of the light down toward the subject. If I'll be adding a separate fill source, I place the strip light so the top of the subject's head is at the same height as the middle of the box. For this setup, I position the strip light flat to the subject.

Strip light positioned vertically for a different look.

Sometimes, I even use the strip light from a lower angle with a softbox over the camera for a modified butterfly lighting look.

These are just starting places for your own tests. You will find that your positioning might vary as you define your own styles of lighting.

ON THE FLOOR

One setup I love doing with the strip light involves having my model lie on the ground. I then place the strip light on the floor (as seen on the facing page). For this setup, the strip light works well because it has a harder look than a traditional softbox but without the strong shadows that would be seen with a grid spot. (*Note: You can get the same look with a standing subject. Just position the subject directly against a white wall and put the strip light right up against the same wall.*)

▼ FOR FURTHER STUDY

I find that the narrow band of light from a strip box is especially well suited for fashion/ glamour portraits of women. In all of these images, a softbox was added on the floor for fill (as you can see in the bottom image on this page).

64

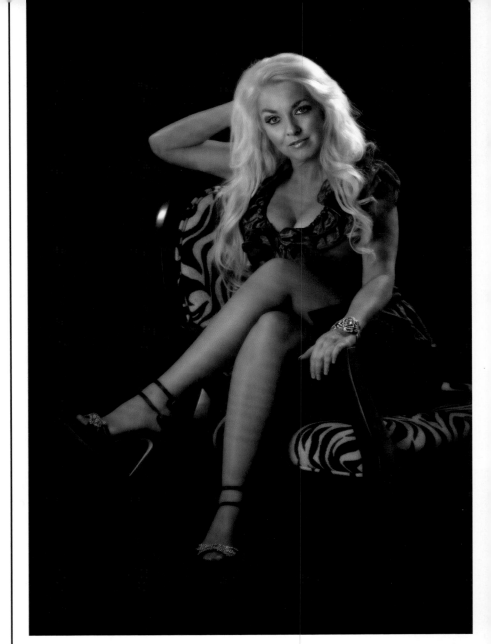

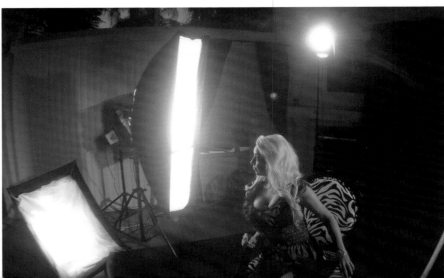

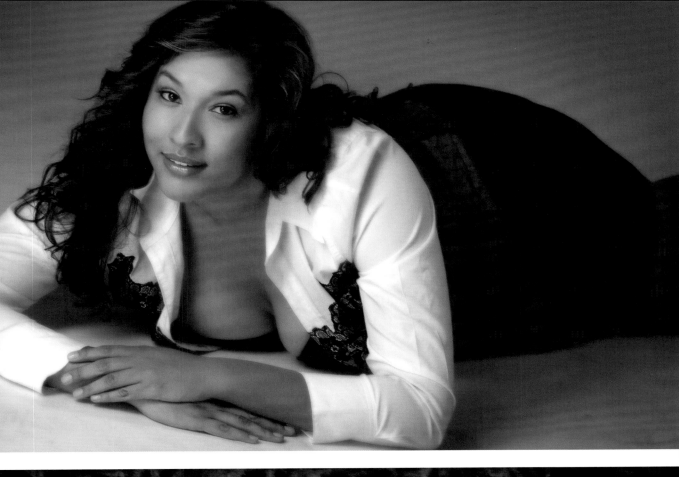

25 CATCHLIGHTS

Your primary objective in positioning the main light is to properly light the eyes—the focal point of virtually all portraits. But how do you know when the eyes are properly lit?

PRINT JUDGES VS. CLIENTS

Every ten years or so, it seems like a group of photographers (often print competition judges) gets together to decide on the "correct" placement of catchlights. For years, the eyes were to have only one catchlight in the upper right or left quarter. The current view on catchlights is that there should be one catchlight in the upper left or right quarter of the eye, with a slight crescent shaped catchlight in the lower quarter of the eye on the opposite side. If a print is to score well in a print competition, it should have the current "correct" catchlight.

This is the world according to print judges, though. Personally, I live in a world judged by clients—and they don't hand out ribbons, they pay me in cash. These real-world judges aren't flawless (unlike the models often seen in print competition images), so you have to know what you are doing to make them look good. The rewards, however, can be much more meaningful.

Now, I've just had some fun at the expense of print judging—but many people do find that print contests help them grow. If that's the case with you, then competing is a great idea. The point I'm trying to make is that you have to keep yourself grounded in reality and focused on what pays the bills. Do the prints that you enter for competition sell well? Does the style of photography that sells well for you also score well in competition? If so, by entering competitions, you are improving your photographic style—a style you know is salable in your marketplace.

POSITIONING THE CATCHLIGHT

Going back to the eyes—the eyes should always have the predominant catchlight in the upper right or left quarter of the eye. These catchlights should be the same size in each eye (when one catchlight is smaller than the other, it creates the illusion that one eye is actually smaller than the other). Pay attention to how the catchlights change with the pose, since this often diminishes the appearance of the predominant catchlight in one eye more than in the other. You must study the eyes of your subject and adjust your main light until the catchlights are in the proper position and appear to be the same size.

When I start training a young photographer, I find that the easiest way to have them light the eyes properly is to have them position the main light and raise it to a height that shows no catchlights in the subject's eyes. At this point, they slowly start to lower the light until they see the catchlights in the correct position, with the intensity that is needed. Often long, thick eyelashes act like the brim of a baseball cap. Instead of creating a shadow on the forehead, however, they lessen the intensity of the catchlights in the eyes. As you would with a hat, lower the light enough to get light under the obstruction.

Once you've placed the main light as described in the previous section, you'll see the eyes start to come alive. But don't stop there! At this point, the eyes are only illuminated from one point: the main light. With just this light, the eye color will only be visible with light-blue eyes; any other eye color will be lost.

A SECOND LIGHT SOURCE

I want to see the color in *every* subject's eyes, so I bring in a second source of light from below the subject to light the lower part of the eye. This can be a reflector, a piece of foamcore board, or a softbox. The intensity of this light should be less than the main light, because the main light should produce the predominant catchlight.

THE RATIO

The ratio between these two lights varies depending on how reflective the subject's eyes are. Usually, the lower light/reflector is metered at $1\frac{1}{2}$ stops below the main light. If the main is f/16, for example, the lower accent light would read f/8.5. This can change to a 1-stop difference if the subject's eyes don't reflect light well.

A SALABLE LOOK

The subject's eyes are the true indicator of good lighting. When you see catchlights in the correct main-light position and secondary catchlights in the lower part of the eyes (with visible eye color showing in at least half the eye surface), you will know that you have created a salable portrait.

HOW MUCH RETOUCHING?

Another consideration you need to make when selecting your main light source (and its position) is how much time you want to spend enhancing the images you take.

WATCH THE SHADOWING

While I don't think it is worth using ultra-soft light to soften the imperfections of the face (because simple retouching has to be done anyway and takes very little time), higher contrast from the main light can create excessive shadowing that must be dealt with in Photoshop.

TRANSFORMATIONS ▶ Back in the days of film, there was a famous photographer here in California who was known for his elegant, nearly life-size portraits—and the amount he charged for them. I was taking a tour through a large photo lab when the guide stopped and explained that a particular stack of canvases belonged to this prestigious photographer.

The large canvas prints (printed with only negative retouching) looked incredibly rough. There was very heavy shadowing on the sides of the nose and the shadow-side eye socket—along with black shadowing on the side of the face. These canvases were on their way to the photographer's artists, who converted the rough shots into spectacular works of art. When I remarked on this, the person giving me the tour said, "It's the artists who transform the images. They're the ones who should receive the praise and be asked to speak at conferences!"

Of course, the process this photographer relied on years ago was no different than the one many photographers overuse with Photoshop today.

TIME IS MONEY

Today, thanks to digital capture and Photoshop, it's all too common to see the computer being used to fix the mistakes of the photographer. But how much of your and/or your staff's time

are you willing to give up correcting excessive shadowing? Or to restore critical focus to the image?

I want to create images in my camera that are 95 percent as good as the final images that leave my studio. Straight out of the camera, these shots require only simply retouching of the lines, circles, and blemishes on the subjects themselves. We don't use retouching to correct mistakes in lighting that should have been fixed in the camera room. We are *photographers*; we create in the camera, not on the computer.

Therefore, I look for a main light that provides a nice balance between soft and hard lighting. I want a usable shadow that is heavier than what most portrait photographers use, but not so heavy that I need to use postproduction enhancement to make the portraits salable.

In most portrait lighting setups, when we position the main light and pose the client, one side of the face is lit (this is called the highlight side) and the other side of the face is unlit (this is the shadow side). Even if the light you are using is very soft, if you put it to one side of the subject, it has direction and creates shadow.

How Much?

You must determine how much shadowing you want. Do you want to see detail in the darkest shadow areas? Or do you/your clients like a shadow without detail for a more dramatic look? It is your style, but it's your client's photograph—something they must live with for the rest of their lives—so choose wisely.

Potential Problems

Keep in mind that your eyes can see shadow detail that neither film nor image sensors are capable of recording. They simply can't record the full range of colors, from the brightest highlight to the darkest shadow, our vision can perceive.

If a portrait was comprised only of bright highlight areas and deep shadows, the image would be striking because of the contrast, but it would lack depth. The transition area, therefore, is what creates a feeling of depth, lending dimension and a sense of realism.

Unfortunately, digital capture doesn't always do a great job recording this area, often lacking the smoothness that we saw with film. Essentially, the digital camera doesn't see the full number of tones. Instead, it records a compressed tonal range, and the image seems to leap abruptly from highlight to shadow.

As the skin darkens from highlight to shadow, the skin tones also tend to pick up other subtle tones; often, these areas end up looking greenish. This is just one of the many little quirks of working with digital files—and, when it appears, it's an issue we typically need to correct during postproduction.

Dark shadows add a sense of strength and drama to the image.

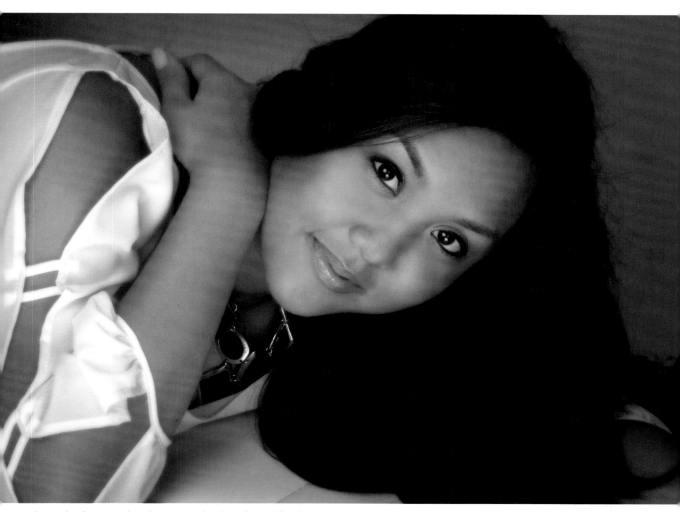

Lighter shadows make the image look soft and fresh.

CONTROLLING THE SHADOW

The size and darkness of the shadow depends on the softness of the light, which in turn depends on the size of the light source relative to the subject. To increase the shadowing on any subject, simply pull the light away from the subject and the light will become more contrasty, increasing the shadowing (the light becomes smaller relative to the subject).

To decrease the shadowing, one approach is to pull the light closer to the subject so the light will become softer (the light becomes larger relative to the subject).

The more common technique, however, is to add an additional source of light for fill. You can fill the shadows with light from a strobe or you can fill it with light bounced out of a reflector—the choice is yours. Either way, adding fill will help the camera capture the more subtle tonal variations you want to see in a professional image. Continue on to sections 29 through 31 for more information on fill lighting.

▼ FOR FURTHER STUDY

There's no magic solution to how much or how little fill you should use. Sometimes, a bright, open look is perfect for your client and the end use of the portrait. Other times, shadows are needed to conceal problem areas or enhance the mood and drama of the image.

74

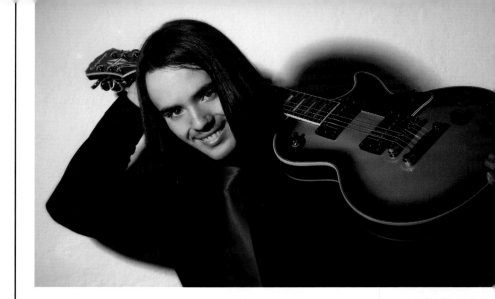

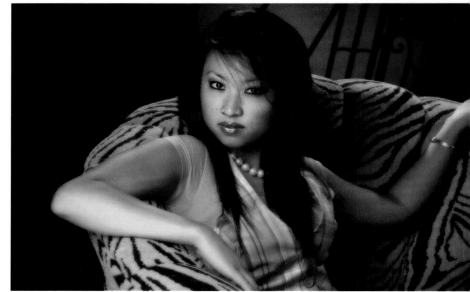

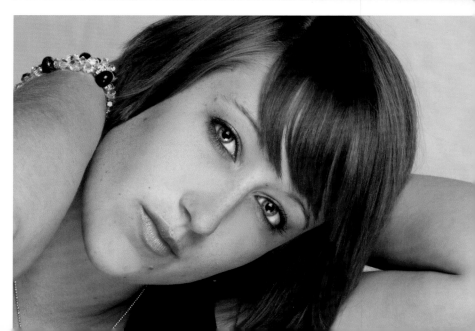

29 ADDING FILL: FLASH

Shadows can be used to hide flaws on the body (we'll explore this in further detail in sections 47 through 49). When it comes to lighting the face, however, excessive shadows are distracting. To create images that our clients will buy, we frequently need to fill (add light to) the shadow areas on the face. We can do this by adding a second light source or by adding a reflector to bounce back some of the output from the main light. Let's start with flash and look at how we set it to fill the shadows to just the right level.

So, How Much Fill Is "Right?"

When it comes to creating great lighting, we all want the secret formula—that lighting recipe that works with every client, every time. We want to get on the fast track to lighting success.

It seems that, at some point, educators got together and decided to present what they considered a cut-and-dried approach to simple lighting. These "lighting experts" began teaching students about light ratios. I was taught to use a 3:1 lighting ratio for undiffused portraits and a 4:1 lighting ratio if I was going to diffuse the image. I was excited! Finally I had found a formula that was easy enough for me to fully understand. (More on light ratios and how to calculate them in sections 32 and 33.)

Well, I faithfully began working with lighting ratios to get that "foolproof" lighting all new photographers are after. Unfortunately, I began to notice a pattern: clients who had a fair, suntanned, or olive complexion looked pretty good, but clients with darker skin tones looked too dark. The shadows were deep and were not filled nearly as much as they should have been. Then it came to me: if black absorbs light and white reflects light, how can a person with very pale skin need the same amount of fill light as a person with chocolate-brown skin? Wouldn't the shadow on the light skin be brighter than the shadow on the dark skin? (See section 36 for a test using this theory.)

If all of our subjects had sun-kissed, Caucasian skin tones and none had a long nose, deep-set

A softbox was added on the floor (see facing page) to fill in the shadows from the Halo main light.

eyes, or any other such issues—and we used flash fill—we could use those ratios as the standard for our setups. In the real world, our clients' features and colorations differ wildly, so we need a variety of different lighting ratios, depending on the shade of skin and the configuration of the subject's face.

This doesn't fit into the fast-track formula theory of lighting—but one way to simplify the situation is to use reflected fill. We'll look at that in the following section.

LIGHTS, CAMERA, ACTION! ▶ The pop of a studio flash seems more glamorous to clients than the other lighting choices, and in this business, creating the feeling that a client is experiencing their 15 minutes of fame is important. If you are starting out and are building a studio, consider buying flash. If you already have equipment, work with what you have.

When I realized I wasn't getting consistent flash-fill results with every subject (see section 29), I started using a reflector to fill the shadow. The advantage of this is that the fill is proportionate, meaning if you like the look of the main light and shadow with the modeling lights on (understanding how the camera sees, of course), you will like the image when it is taken—no matter what your light settings are. While using fill does require some training, it is a much more intuitive system than trying to guess what lighting ratio to use for a particular person's skin tone and facial structure.

CHOOSING A REFLECTOR

If you want to use a reflector panel to fill in the shadow areas, you have a few choices to make.

Reflectors are available in white, silver, or gold. I suggest that you avoid using gold reflectors, because the color of the light on the subject will be altered. If you want to see a warmer glow on the skin, it would be best to make that change in Photoshop.

The choice of white or silver reflector will greatly depend on two factors: what you own and how far the reflector needs to be placed from the subject. In the studio, I have a 6-foot silver/white reflector. I use the white side when I want soft fill light and the reflector can be placed close to the subject (like in a head-and-shoulders pose).

The silver side is used when I need a higher volume of light to fill the shadows or when the reflector must be placed farther away from the

For the images on the facing page, the main light was from a Halo. The fill light was from a bank of three reflectors below the subject's face.

subject (like in a full-length pose). The silver side produces a harder, more specular look in the fill light. I always use the silver side of the reflector when photographing a subject with very dark skin and when a dark-haired subject is dressed in very dark clothing. The slight shimmer from the silver adds extra dimension to these darker tones.

The size of the reflector is also important when you are creating precision lighting. Working with a 6-foot reflector is great when you want to fill the shadows over the length of a standing subject's body, but when you want to fill only the face, leaving the rest of the body in shadow, a small reflector is a better choice.

There are a variety of tools available on the market to help you position your reflector, so you won't need an assistant to hold it for you. I often lean a rigid reflector against a light stand or hook the cloth hand grip over the top of a light stand.

When to Add Fill

Not every shot will require fill. I never add fill automatically; I look at the subject posed in the scene. When I am shooting in a bright or high-key area with a fair-skinned person, the white surroundings all reflect so much light that they provide plenty of fill with no help from me. In other scenarios, when the shadows are too heavy, I add the appropriate fill.

It takes time to build the confidence to trust your own judgment. That is why young photographers often look for "paint by numbers" lighting systems that work every time, with every client. Unfortunately, nothing works *every* time with *every* client.

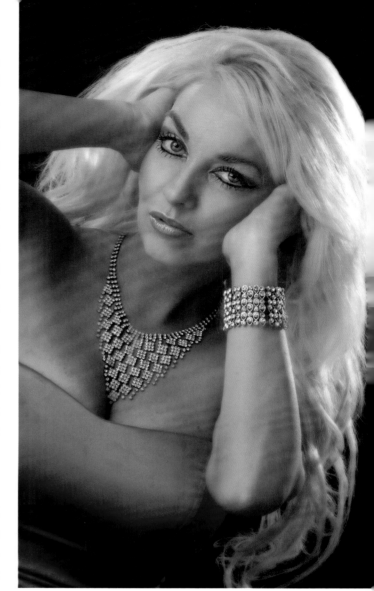

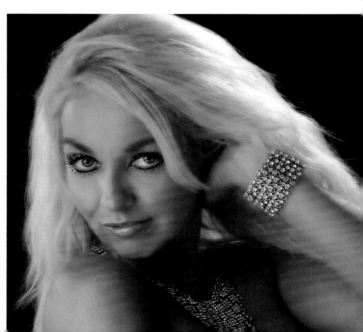

HALO WITH FILL

Halo with Reflected Fill

Like most studios, I rely on one general portrait lighting style for the majority of my traditional portraits. At my studio, this setup consists of a large Halo main light with a silver/white reflector for fill. About two-thirds of the time, my fill source is a trifold reflector that I purchased from Westcott. I prefer the look of portraits that have light coming from in front of and slightly below the subject. This applies to images of both men and women.

Halo with Softbox Fill

A similar lighting effect is achieved for many of my headshots, full-length traditional poses, and group shots by replacing the trifold reflector with a 30x40-inch softbox on the floor.

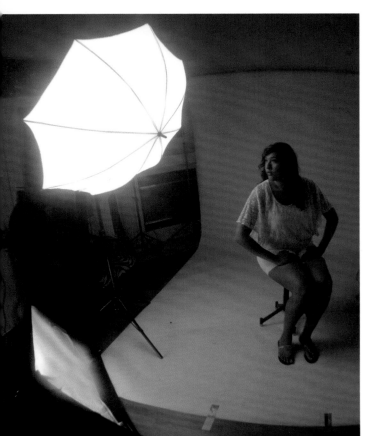

When using the 30x40-inch floor box for full-length images, you have to decide whether to have the floor light directly underneath the main light or move it more toward the camera position. The best way to decide is to look at the effect of the main light. If the eyes just need a little sparkle and the whole photo needs to be a little more glamorous, then I place the floor light under the main light. If the shadow side of the subject's face (especially the eye) is very dark, I adjust the floor light's placement more toward the camera. For most portraits, the floor light is actually placed somewhere in between these two positions.

How to Choose

Photographers often ask me to explain how I choose between the trifold reflector and the 30x40-inch floor box for fill—and in what cases I choose not to use either. The only answer is that each person's face is unique. As photographers, we like to think once we come up with a lighting "system," for lack of a better word, it will make each person we photograph look great. The truth is, every face you photograph will be different and require you to try a different approach to lighting.

In general, though, if the eyes don't reflect light well—if you see little or no color in the eyes when the main light is properly positioned (see section 25)—it's time to add the trifold reflector or floor box. I would say that most people look great with this additional fill light coming in from

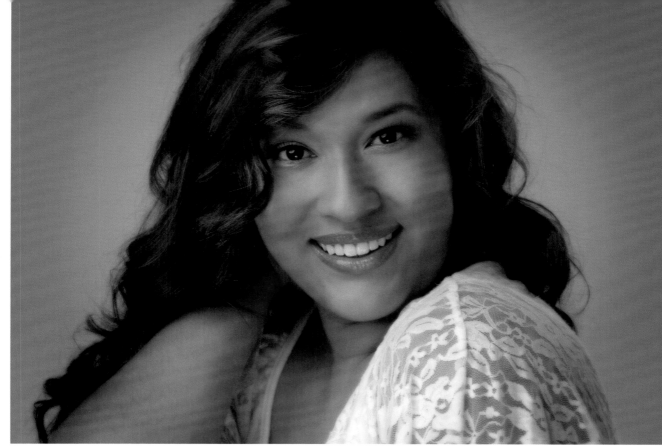

As seen on the facing page, a Halo main light with softbox fill was used to create this portrait.

a lower angle. It brightens the eyes, smooths the skin, and adds a luster to the lips—which, even in men, makes the skin of the lips look good and healthy.

The downside of this extra light is that it tends to fill the contours of the face. For most people, this is a good thing, but for some people—especially those with high cheekbones—I prefer the look of the lighting without either the trifold reflector or 30x40-inch softbox underneath.

I USE IT BECAUSE IT SELLS

Whether I am photographing a high school senior, a businessperson, or a boudoir session, I use this light for a majority of my images. Some young photographers might think this is boring,

but these are the portraits that the clients typically buy. In fact, about 70 percent of my sales come from portraits with this type of lighting.

MAXIMIZE THE SESSION ▶ If a woman wants to schedule a boudoir session, we have her bring in at least one outfit that isn't for the boudoir session (something casual or dressy). We do this because, in the salesroom, we always find that people want to buy additional photographs—images for different end uses or people other than the original recipient. Boudoir clients want to buy a portrait for their parents or an adult child; business-portrait clients want to buy images for their spouse or family. By encouraging clients to include other types of clothing, and producing these other types of images, you increase your sales from each session.

▼
FOR
FURTHER
STUDY

Pairing a Halo main light with a softbox on the floor for fill (as seen in the bottom image on this page) gives me great results for a variety of session types. A large percentage of the images purchased at my studio are made with precisely this setup.

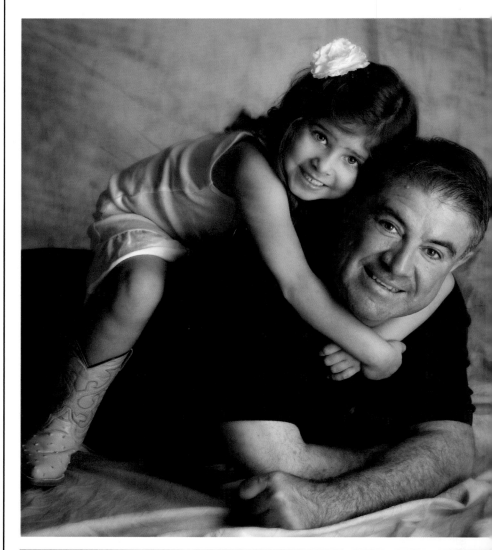

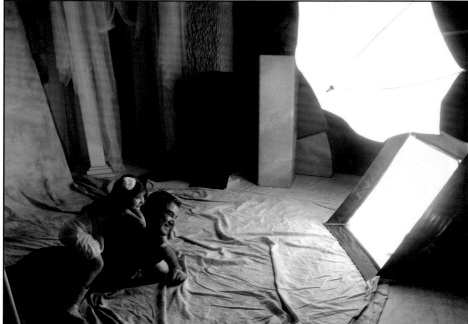

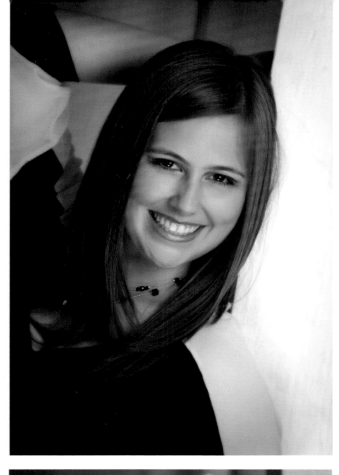
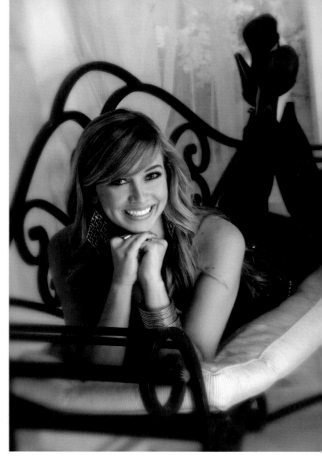

32 METERING

The device seen below is called a light meter. I realize that pointing this out sounds like a joke—but it almost isn't. Although most photographers have one of these little devices, many have quit using them. Believe it or not, shooting a test frame and looking at the back of your camera is *not* the same thing as metering/controlling your lighting.

HOW TO METER

While metering is a simple process, photographers can get really confused doing it. Like almost everything in photography, there are many ways to achieve the same end result. I prefer my way, because I have done it forever and it's always been right.

When metering, I stand where the subject will be and point the diffused sensor directly at one light (with all the other lights off). One at a time, I test each light in the setup to give me the amount of light I want.

KNOW WHAT YOU WANT

That statement is important, so I'll repeat it: *I test each light in the setup to give me the amount of light I want.* As the photographer, you should decide on the f-stop you want and then adjust the light accordingly. You should not just meter and say, "Oh well, what the heck? Looks like I'll be shooting at f/11."

A VARIETY OF STYLES ▶ While most of my sales come from traditionally lit images, the 30 percent of sales that come from all the other styles of lighting are what keep me from losing my mind. We all get to a point where we feel like we work in a photo factory, cranking out one session after another. When you do ten sessions a day, they all start looking the same by the end of the week, no matter how many props and backgrounds you have and no matter how many styles of lighting you use.

The days are over when a photographer can develop one style of lighting and use it for everything. Through the media all around us, our consumers have been exposed to the most creative images in the world—and then you are going to offer them *one* style of lighting to produce *one* look? That just won't fly in today's market.

While truly mastering even one style of lighting still puts you ahead of many of the shooters in today's marketplace (saturated as it is by "semi-pros"), it doesn't make you stand out in this crowded industry.

So look for ways to push yourself. Experiment with new main light modifiers and positions—and, as we move forward to add even more lights—keep your mind open to new ideas that might enhance your work (and your sales).

That's actually the hard part of metering: knowing what f-stop you *want* the light to meter. To determine how you want your lights set, you need to know what look you are trying to produce. Again, you have to previsualize.

The first reading you take should be of the main light. For this light, you want to pick a setting based on your shooting aperture. For example, if you decide that your portrait needs the depth of field your current lens will provide at f/4, you'll want to meter your main light to read f/4.

Every other light in the setup will then be metered based on that reading of the main light source. If you want the background to look as it does in normal room lights, the background light should be set to meter at f/4. If you want to lighten or darken the background, adjust its output up or down relative to the main light.

The hair lights, accent lights, and/or fill light will also be metered and set based on the reading of the main light source. Generally, I set my hair and accent lights ½ stop below the main light, because light tends to appear brighter when it's directed back at the camera.

The Next Step

You don't want to go through this entire process for every setup, with every client. In the next section, we'll look at how to streamline the exposure/metering process.

LIGHT RATIOS

CALCULATING LIGHT RATIOS

Light ratios are used to describe the intensity of the main light relative to the intensity of the fill light. If a portrait is said to have a 4:1 ratio, then the highlight side (lit by the main light) is four times brighter than the shadow side.

This is where things get tricky. You might think, "Well, if the highlight side is four times brighter than the shadow side, there must be four stops more light falling on it." Not true. When you adjust your light so that your meter reads 1 stop higher, you are actually throwing *twice* as much light on the subject. Therefore, you only need to adjust your light so that it me-

ters 2 stops higher than the fill to create a 4:1 ratio. When you have a 3:1 ratio, the main light is outputting light that, if metered, would be 1.5 stops higher than the fill light. Higher ratios indicate a greater difference in intensity.

WHAT'S THE "RIGHT" RATIO?

There are a lot of variables to consider when thinking about the ratio of lighting (or the amount of fill relative to the main light). First, the ratio changes as the subject's skin tone lightens or darkens; darker skin goes from highlight to the darkest shadow faster than light skin does. That means that, to immediately know what ra-

A medium ratio provides just enough shadow to reveal the contours of the face.

At a relatively high ratio, some detail begins to be lost—but the overall effect is quite dramatic.

tio of lighting to use, you would have to test *all* the skins tones reflected in your client base.

Lighting ratios also change with the type of lighting you use. While a fair-skinned person being lit with a softbox might look great with a 3:1 ratio, that same 3:1 lighting ratio will not fill the shadow properly if you change the main light from a softbox to a parabolic—or even if you add a grid to the softbox. The harder light will produce heavier/darker shadows and require more fill (meaning a lower lighting ratio, like 2:1).

THINK TWICE

The sheer number of variables involved here are one reason why my fill source of choice is so often a reflector. In the subdued lighting of a studio, what you see with your eyes is exactly what you get. It is always proportionate. If it looks good with the modeling light on, it will look good regardless of the meter reading of the main light source. Since you are not working with lighting ratios but with your eyes, adjusting the fill for each subject and each pose and each clothing or background change becomes much more fluid and intuitive.

CONSISTENT EXPOSURES

Young photographers don't always understand the importance of *consistency* in portrait lighting. They like winging it, because they think it is in some way "artsy."

FREE ≠ EASY

This "artsy" approach is the very reason that so many photographers have such a hard time with studio lighting. They never take the time to properly set up and test their lighting to establish a standardized working environment. Trust

me—I understand this. When I first started out, I would either focus on the client and position my lights where I thought they should be (which produced images that were all over the place in the terms of exposure) or I would drive my client crazy by metering each light for each shot.

Ultimately, what seemed like a free and creative approach was actually making my life a lot harder. I soon realized an important fact: only when you have done away with the variables and are able to predict exactly what the outcome will be are you free to be creative and truly use light to enhance a subject.

Previews might be good for double checking the results of your lighting, but to master lighting you have to meter, test, and learn how to get consistent results from your lighting setup.

THE STRING APPROACH

The first time you work in a studio space, you will have to go through a complete metering process (see section 36). As you test each light, though, tie one end of a string to each movable light stand and cut the string off at the distance where the client will be positioned. If you follow this process for each light, it will be unnecessary to meter each time you change subjects or poses. You simply check the distance of each light with the string. (*Note:* Do your measurements while you are waiting for the client to finish changing so you aren't holding strings up to a client's face. Measuring to the middle of the posing stool will be just fine!)

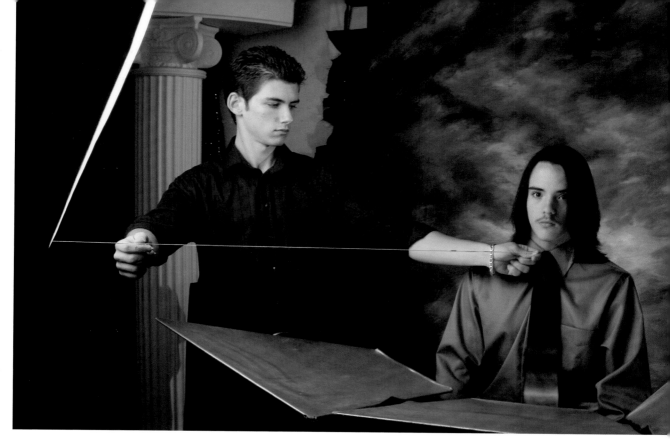

You can get creative with this and have different marks on the string for different distances. I used to have up to three markings for the most common settings I used. For example, I metered my lighting to give me a 3:1 lighting ratio when the main light was placed at a distance that was the full length of the string from the client. Then, I also placed a red dot at the spot on the main-light string that would give me a 4:1 lighting ratio. This was an effective way to get consistent exposures without having to meter each light with each background or pose change.

Some photographers use a variation of this approach, putting marks or duct tape on the floor to make sure their lights are the correct distance from the subject (or background) to produce the desired setting.

BENEFIT OF EXPERIENCE ▶ In the set-up shots shown in this book, you'll notice that you don't see any strings. Once you've worked in a studio for the number of years I have, you too will know the distance at which to place the lights to get the setting you want for most shots. The idea here is that correct metering isn't difficult, but it *does* need to be done if you are going to produce consistent, predictable results.

VARIABLES OF METERING

I've already noted that there are numerous variables you must consider when metering. Two of the most important ones are the client's skin tone and the tone/color of their clothing.

THE PROOF IS IN THE PRINTS

For years, photographers told me there was little or no difference in exposure needed when changing from photographing a fair-skinned person to a dark-skinned person. It wasn't until I put in a lab and started printing my own dance and prom portraits that I saw how much difference the tone of clothing and the shade of skin made. Since event images are all shot with standardized lighting and camera settings, this was the only variable that could account for the differences.

To look properly exposed, a person with a dark complexion would have to be printed about a ½ stop lighter than a suntanned person—even when shot at exactly the same exposure. Put that dark-skinned person in a black tuxedo or dress and the exposure compensation was even greater. The inverse was true for subjects with very fair complexions. We typically had to print these couples about a ½ stop darker to ensure they didn't look like ghosts. Again, adding a white dress or tuxedo to the equation made the situation even worse—the subjects' skin would look almost translucent.

THINK LIKE A PRO

While the digital preview allows you to identify these variables more easily than we could with film, the professional photographer still has to keep these variables in mind when setting up the lighting—especially when photographing more than one person. Imagine you have a very fair bride, so fair you'd think sun had never touched her face. She is, of course, wearing a glowing white dress. Her groom, a handsome man with a very dark complexion, is dressed in a dashing black tuxedo. What do you do? Some photographers would just think, "Dude—I will, like, totally fix it in Photoshop!" However, since we are *professionals*, we should be able to figure out a way to capture both subjects correctly in the camera. Why waste away our lives sitting in front of a computer fixing simple problems we could have addressed in the camera?

SUBJECT PLACEMENT IS KEY

Here's the solution: when you set up your lighting, put the main light on the side of the darker-skinned person (or put the darker-skinned person closest to the main light source). This lets you take advantage of the natural light falloff to balance the darker skin and clothing with the lighter skin and clothing.

You'd do the same thing if both members of your couple had light complexions but he was in the same black tuxedo. You would put him nearer to the main light, knowing that the black tuxedo would darken his skin tone, while the white dress would make the fair bride look even fairer. This might seem like a small thing—too small to worry about—but can you imagine the

Placing the main and fill lights to camera right (the side with the subject in darker clothing) let me take advantage of the light falloff to keep the exposure more even across the subjects.

number of hours per year this could save a busy wedding/family photographer in editing?

ANOTHER USE FOR
SUBJECT PLACEMENT

Selecting the proper placement of the subjects relative to the lighting is just another part of truly understanding lighting. Let's imagine another scenario where this would come in handy. This time, imagine you have a family to photograph—but you have only one darker background and two lights. One light will obviously need to be the main light. But you're going to need that second light on the background for separation. The hot-spot it produces on the background provides good separation in the middle of the background, but it falls off significantly toward the outer edges of the background. How are you going to approach this session? The best way would be to place the subjects with the lightest-colored clothing (or hair) toward the edges of the background. Their lighter tonalities will provide a natural degree of separation.

While we can all see the logic in this placement, during the stress of a session, it's easy to forget such obvious choices. That leads to excessive editing, as we try to lighten the dark background behind the subjects with dark hair and clothing.

You must understand the characteristics of the light produced by the equipment you have, rather than hoping there is some kind of magical new light modifier that will produce the perfect results.

To do this, you'll need to test your lighting so you know exactly what results you will get. It sounds so simple—almost elementary—but very few photographers take the time to test out their lighting completely.

SUBJECT 1: MAIN LIGHT

To test your lighting, start with a single main-light source and no other lights on. Place a light-toned (not white) background behind the subject so that you will not need additional lights for separation. Have all the room lights turned off in the camera area and the windows blacked out; you must be able to see your light to control it.

Put a test subject in a basic pose and give them a tabletop to lean on so they don't get un-

comfortable. Ask them to wear a medium-gray top (white fabric will reflect light up and act as a fill-light source; black fabric will take light away through subtractive lighting).

Start with your main light at a 90 degree angle to the subject, then adjust the height as discussed in section 25 and take a shot. Put a piece of duct tape under the main post of your light stand. Then, move the main light 6 inches closer to the camera position, leaving it at the same height, and take another shot. Again, put duct tape on the floor under the center post of your light stand. Repeat this procedure until your light box is at least to the 45 degree position, with all your marks on the floor. (You may want to keep some notes as to the placement of each shot and the order it was in.)

SUBJECT 1: MAIN LIGHT WITH FILL

Next, repeat the process—except this time, adding your fill light. If you use flash, start with a high lighting ratio like 6:1 (the main light 3 stops greater than the fill). If you are using reflected fill, start with the reflector at a distance where you can see very little fill with your eyes. For a silver reflector, this may be 6 feet from the subject; for a white reflector, this may be 4 feet from the subject (but a great deal will depend on how you see). Repeat the testing process and mark your reflector position with a piece of duct tape on the floor. Now, move your reflector 6 inches closer and repeat the process, marking the floor. Continue this until the reflector is 1 to 2 feet away

from the subject—or you have gone in ½-stop increments down to a 2:1 lighting ratio.

REPEAT WITH SUBJECT 2

Once you complete this testing with your first test subject, get a second test subject with the opposite skin tone—meaning that, if you were working with a dark-skinned person, the second person should be fair-skinned, or vice versa. Repeat the complete process (which will go faster since the floor is already marked).

PRINT AND EVALUATE

When you have taken all the images, make a print of each test image—a big enough print that you can really see the lighting. Terrible lighting might be overlooked in a wallet-size print or even in a larger print where the face size is small, but with an 8x10, 11x14, or larger print (with a larger face size) you can easily make the distinction between good lighting and bad.

DEVELOPING GOOD HABITS

This series of tests doesn't provide you with a "paint by numbers" lighting kit, but it allows you to set up a range of lighting positions and fill amounts for both lighter and darker skin tones (setups that look good to you), while forcing you to get into a habit of adjusting your lighting for each client and each pose.

The reason we only use the main light, and then the main light with fill, is to get back to the basic lighting structure. We don't want additional light sources to mask what is fundamentally bad lighting. The marks on your floor will also help you achieve a similar lighting effect for the desired outcomes during the pressure of a paying session, helping you execute setups that you might forget if you were winging it. (*Note:* If you take a peek at floors in some of the overview shots that appear in this book, you'll notice I don't have tape on my floors. After 20 years, you can peel your tape off, too!)

BACKGROUND LIGHT

When you turn on your main light, you raise the quantity of light on the subject. The area behind the subject, however, will then appear darker in comparison. To attain a balanced exposure, this means you will need to use a background light to increase the light levels in the background. Using a background light may seem pretty simple. However, using it correctly can be a challenge for new photographers.

INTENSITY

If you want the background to appear as it does normally to your eyes, you will need to add the same amount of light that you used on the subject's face (if your main light reads f/8, the light

Once the subject is lit, the background often requires light to keep the exposure in balance.

on the background should read f/8). Of course, there's no reason the background has to match "reality." You can easily brighten or darken the background's appearance by increasing or decreasing the amount of light on it relative to the main light source. (*Note:* If you paint your background a medium tone, you can darken it to near black or brighten it to near white by changing the amount of light you add.)

MODIFIERS

Backgrounds with strong lines look best when illuminated with a soft, even light. This is achieved by using a bounce light attachment to soften the light or using your flash without the parabolic reflector. If you are working with a background without distinct lines, you might want to create a hot spot behind the subject. This is done with a parabolic reflector, which focuses the light onto a spot behind where the subject will be positioned. The reflector allows the light to spread softly, becoming darker as it moves outward from the center. I prefer this style of background light because it helps to separate the subject from the background. Also, it can help you to direct the viewer's eye right where you want it (more on this in section 54).

PLACEMENT

The height and angle of the background light can also change the characteristics of the light. When the light is directly behind the subject and aimed at the background, the light beam will

Directed squarely at the background, the background light creates a sphere of illumination (top). Placing the background light higher and at a downward angle produces a fan-shaped spread of light (bottom).

create a circular pattern of light. This will ring the subject and fall off as it moves outward from the center. You can also lower the light and angle it upward to create a fan-shaped beam of light. This allows for better separation than placing the light right behind the subject. You can also put the background light on the side or top of the background and have the beam of light come in from a different angle to achieve different looks with the same background.

CONSIDER THE BACKGROUND

Before setting up your lights, consider the tone of your backdrop. Medium to dark-toned backgrounds can be lit similarly. White backgrounds need to be approached differently; if you are not careful, a white wall behind a subject can reflect light from all around the subject's head back into the lens. If you're shooting digitally, meter the white area and adjust your lighting so that it reads 1/2 stop less than the main light to ensure it is not reflecting into your lens and compromising your images. You can create a simple action to brighten and blur your white wall/background in postproduction.

We repaint the white floor in our studio every two business days. Because of the foot traffic, plus the Harley and the Viper (these are popular props for our senior sessions), the floor looks terrible most of the time. We simply run an action that brightens and blurs the floor to do away with this problem in the final portraits.

▼ FOR FURTHER STUDY

How much or how little background lighting and separation you want to add should be determined by looking at your subject. Be sure not to accentuate any areas your subject won't want to see in their prints.

A lack of separation (also called tonal merger) between the subject and the background is a mistake that is commonly made by new photographers—and it is one that clients hate. In addition to adding a background, creating adequate separation may also require the addition of a hair light. Properly separating the client from the background is critical.

MAKE IT A PRIORITY

There may be times when you don't have enough lights to illuminate the set as you would like. After the main light (with a reflector for fill) and the background light, the hair light is the most important. Not only will using it allow you to ensure that your subject doesn't blend into the background, but it will add a nice glimmer to the hair, which helps to make your portraits look more polished and professional.

PLACEMENT

I always thought the placement of this light was pretty easy to understand, but I often see photographers putting the hair light right above the background, angled back toward the hair. This means that the light is also angled back toward the lens—especially when the camera is moved closer to the subject. I see other photographers putting the hair light directly overhead, creating highlights on the top of the forehead as well as in the hair. The correct position for the hair light is just behind and above the subject—high enough

to allow the beam of light to be angled down-ward to avoid light hitting the lens.

CONTROLLING

To prevent lens flare, you must control the light source. I prefer to use grids or barn doors to keep the light from striking the lens. Of course, you also need to decide on the characteristics of the light you want to use. Raw light from a reflector can be used, but it may result in a highlight that is too specular/bright. When I use my silver reflector, I often put a white cotton covering over the front to soften the light. You can also use a softbox with louvers or a grid attachment to achieve softer light with control over lens flare.

INTENSITY

Lights directed back toward the lens seem to gain intensity. In other words, if your hair light and main light meter the same, the hair light, which is angled back toward the lens, will appear brighter. Keep this in mind when you meter your hair and accent lights.

The intensity you require from your hair light will change depending on the subject. Black hair requires much more light to highlight than blond hair.

39 ACCENT LIGHTS

Luster Draws the Eye

When I got started in photography, I noticed that when the skin and hair were lustrous in a portrait, the image had a certain allure. Look at any better modeling, fashion, or glamour photograph, and you will see what I mean. This same principle can even be seen in makeup: a gloss over lip color adds a shimmer when the light hits the lips, giving them a more glamorous look in the photo.

The Role of Accent Lights

Accent lights are used to direct the viewer's eye to a certain area and add luster. Because they are typically angled toward the camera and the point of using them is to accent a very specific area of the portrait, you will need to modify these lights

to achieve maximum control. I typically use a small parabolic reflector with barn doors. For most of my portraits, I use at least two accent lights—one on each side of the background and at a height slightly higher than the subject's head level—to accent the hair and side of the body. When I use corrective lighting for a full-length portrait (lighting just the face with the main light), I add a second accent light on each side to accent the hair, shoulders, and legs.

We've already looked extensively at the use of modifiers on main light sources. But the type of modifier you put on background, hair, and accent lights changes the characteristics of these lights, too—as well as the overall look of the lighting in the portrait.

LIGHT MODIFIERS

For hair lights, some photographers use a strip light with white baffle material over the front of the box. This type of light is very soft, so it will add gentle accents on the hair and shoulders but produce little luster on the hair. This type of light might be a good hair light for a bald man, but typically we associate healthy hair with *shine*. The same is true for clothing made of lustrous materials, like leather. We expect to see highlights on the leather to define that it is, in fact, leather.

> **COORDINATION ▶** I personally use a silver reflector for filling the shadows of a higher-contrast main light source. While you can fill the shadow with a white reflector, it is a very soft fill that seems out of step with the main light. I want the characteristics of my main and fill lights to coordinate. The same goes for my hair and accent lights; the characteristics of these lights should somewhat match the characteristics of the main light (soft with soft, hard with hard).

Another problem with a strip light is the lack of control, both on the subjects and in your ability to keep light rays from hitting the camera lens. To add control and contrast to a strip light, many photographers add a grid or louvers to the front panel. This does help with control—and the added contrast produces more of the look a separation light should have.

Personally, I prefer a grid spot for a hair light. It's cheap, controlled, and produces crisp highlights. I add barn doors to the standard size reflector for my accent lights. This control is very important. Remember: many of your clients have parts of their body to which they'd prefer you not bring attention. Barn doors give you both vertical and horizontal control, so you only illuminate what the client's ego can handle seeing.

POSITIONING
HAIR/ACCENT LIGHTS

While the hair light can be in a fixed position on top of the background support or mounted on the ceiling, I prefer for the side accent lights to

be movable. In my studio, clients move a great deal. They are posed at a variety of heights (going from the floor to standing) and also posed in different ways that make it necessary to reposition the accent lights—and to do so quickly. Photographers who are more static in their posing and positioning may simply be able to mount these accent lights on the background support legs at each end of the background and leave them there for most portrait setups.

A problem with fixed hair and accent lights is that they are harder to adjust. You will want to fine-tune the settings as you change clients. One hair light setting might look great for a brunette, but when the next client comes in and she is blond, with a husband who shaves his head (so it's nice and shiny), you will need to power down your hair and accents lights. With a really shiny head or greased down, ultra-slick hair, the overhead hair light might even have to be turned off completely to avoid creating a glaring highlight.

LIGHTING THE SET ▶ A background light does more than just light a background, it can create the illusion of depth where there is none or enhance the apparent depth of a set that actually does have multiple points of focus. In some of my images, I will have more lights illuminating the set than lighting the subject. I like being able to control not only the lightness and darkness of the background or set areas but also the textures and contrast—as well as the separation of the subject.

HOW MANY LIGHTS?

Some photographers ask about the minimum number of lights needed to be able to take a studio-quality portrait. That number would be as low as one—provided you know what you're doing.

That being said, several variables make the real answer to this question a little more difficult. If you want to use a white or light-colored background that can provide separation without being illuminated, you need fewer lights than if you want to photograph against a black background. Against black, you'll need not only a background light to separate the subject from the background but also hair and/or accent lights to further separate the hair and body.

In my opinion, five lights is the maximum number the average photographer should need. This would include a main light, a background light, a hair light, and two accent lights (one on each side of the subject). For fill, as you've seen, a reflector will serve you well.

Again, it comes back to knowing your objective—know what you want to create. The number of lights you need is really determined by

DON'T BUY IT ► Yes, there are some photographers who like to complicate their lives (and look impressive when they give programs) by using countless lights. These same photographers will try to convince you that you need to buy twelve lights and modifiers if you have any hope of creating beautiful portraits. Don't believe the hype; I'm here to tell you it's not true.

what you hope to create, the settings or scenes you are working in, and (of course) your budget.

If your budget is limited, though, don't fret. Honestly, I learned more from being broke and not having all the equipment I "needed" than I ever would have if I'd borrowed money or used a credit card to buy everything I dreamed of owning. Poverty taught me to use my head and make do with what I had. It also taught me that, in the end, the equipment had little to do with the images I created.

Just as the quality of a home has nothing to do with the brand of hammer it was built with, a beautiful portrait has nothing to do with the brand or type of lights that were used. It has everything to do with the creativity and knowledge of the artist using them.

In the next two sections, we'll look at some basic setups using one, two, three, four, and five lights.

BASIC SETUPS

One Light

For a one-light setup, position the subject in front of a white wall (about 4 feet away to avoid a shadow in the final portrait) and add a large light box or umbrella. Use a reflector for fill (you can even put aluminum foil over foamcore to make this reflector). Personally, I would make another reflector for underneath the main light to add a little sparkle to the eyes and smooth the skin. Alternately, you could pose the subject near a corner where you can use the white wall as your reflector. This one-light setup works when shooting with a light-toned background that can provide enough separation for the subject without any additional illumination.

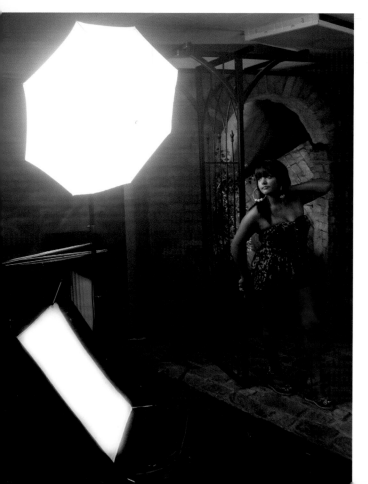

Two Lights

Keep the main light and fill source(s) the same, but add a second light source on the background to brighten it to white (instead of letting it go gray). Or, since you now have a source of separation light, switch to a darker background. This two-light setup works with subjects who have blond or light hair and are dressed in lighter clothing. While you can take a portrait of a person with black hair and in black clothing on a black background, doing so will require a background light with enough power to produce, in the middle of the background, a large enough hot spot for the entire subject to fit into it.

Three Lights

Keep everything the same as in the two-light setup but add a hair light behind and over the head of the subject, pointed back toward the camera. While you can get by with just one or two lights, most photographers consider three lights to be the minimum number of lights that can be used effectively. (I guess those photographers didn't have as humble a beginning as I did!)

Three lights do offer the photographer a very effective setup that can be used in most situations. As we start talking about more lights, though, remember that there are trade-offs. The fewer lights, the fewer mistakes that can be made. Also, the fewer lights you use, the more control you have. As you start adding hair and accent lights, you'll see that they often create problems and end up being more of a distraction

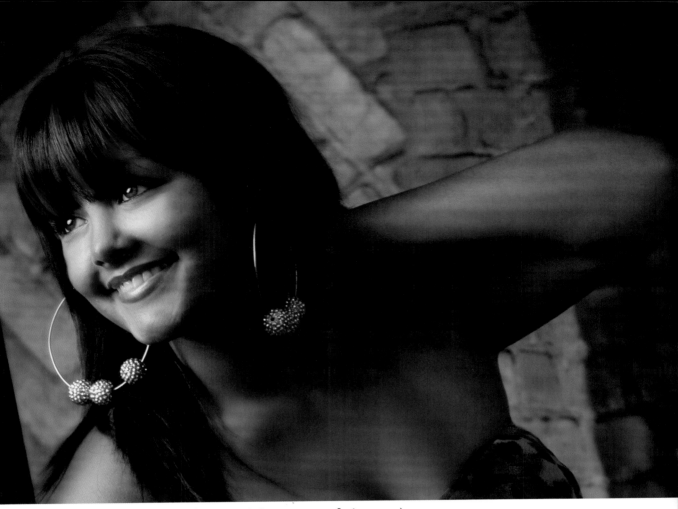

Two lights were used to create this portrait (see setup on facing page).

than a benefit. For instance, a strong side light can add more separation and shine to a woman's hair—but it also might illuminate the top of her shoulder, the side of her face, or some other area you don't want illuminated.

FOUR AND FIVE LIGHTS

The fourth light would be added behind and above the subject, positioned at a 45 degree angle. This accent light should be on a stand that is adjustable from 6 to 8 feet, as you will want to raise and lower the light to control where the light strikes the subject. This light should be fit-ted with barn doors to control precisely where the light will strike.

The fifth light you might want to add would be another accent light. This would be set up in precisely the same way as the fourth light, but on the opposite side of the set.

EXAMPLES

Diagrams showing each of these setups appear in the next section for your reference.

FOR FURTHER STUDY

Now that we've worked through the functions of all the basic lights, let's take a moment for a review (and overview) of how they all work together in some basic portrait setups.

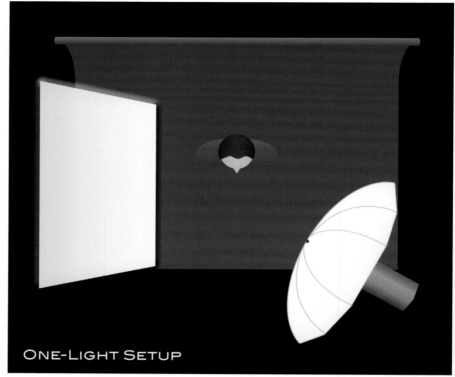

ONE-LIGHT SETUP

Main light, reflector for fill.

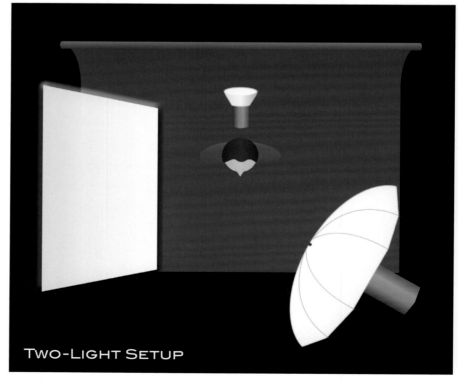

TWO-LIGHT SETUP

Main light, reflector for fill, background light.

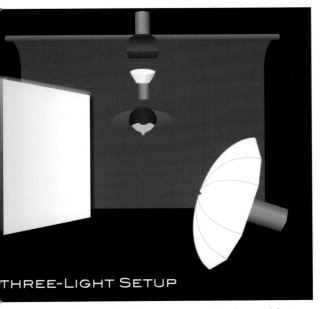

THREE-LIGHT SETUP

Main light, reflector for fill, background light, and hair light.

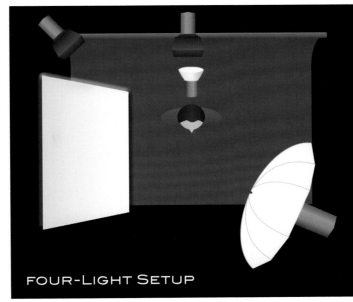

FOUR-LIGHT SETUP

Main light, reflector for fill, background light, hair light, and one accent light.

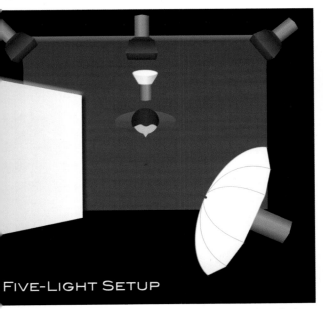

FIVE-LIGHT SETUP

Main light, reflector for fill, background light, hair light, and two accent lights.

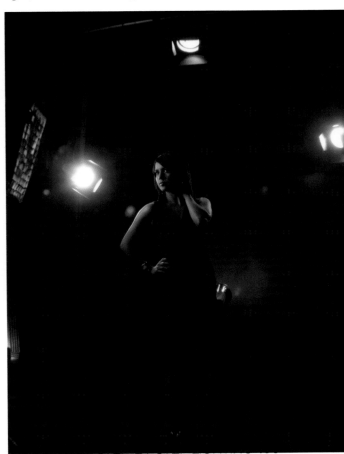

A five-light setup viewed from the camera position.

HOW TO CHOOSE

We've looked at a lot of lights, modifiers, setups, and techniques so far. Are you overwhelmed yet? Don't be. This is where portrait photography really starts to get interesting. This is where you get to begin crafting an interpretation of the client's appearance—which is what a portrait really is.

TWO SIDES OF ONE BAD COIN

It is one thing to learn and practice different styles of lighting, it is another to know when to use each style of lighting and with which clients.

I'm constantly surprised to encounter photographers (usually seasoned ones) who put every client through the same six or eight poses, using the same handful of backgrounds and the same lighting setups. The businesswoman gets the same backgrounds and lighting as the cheerleader. The heavy woman gets the same poses and lighting as the thin woman.

Is that what constitutes a professional portrait session? If so, is it any wonder so many studios have been hurt by the economy and increased competition?

Taking the time to light and pose each client individually will make a huge difference in their satisfaction with the session.

Of course, I have also seen many younger photographers trying so hard not to be like their older counterparts that they really just end up the opposite side of the same coin. Thinking it is artistic and builds creativity to do things "on the fly," they never plan anything. As a result, they are just as surprised as the client when the images come up on the screen! But, hey, if you just shoot the heck out of it, something is bound to look good, right? Without forethought and planning, these younger photographers end up with results that are just as disappointing as those of their older counterparts.

Customizing the Session

Customizing each session to each client is essential for those photographers who want to excel beyond what the "average" shooter does.

This begins by taking the time to develop a game plan. Your strategy should be designed to produce a portrait your unique client will love so much that she is willing to trade a boatload of money for the pleasure of owning it.

To attain this objective, you have to understand the purpose for which the portrait is being created (as covered in section 6), but you must also look realistically at every part of the client—from head to toe—and decide what is in her best interest to show and not to show.

Keep in mind that we are more similar than we are different—no matter how hard we try to be unique. We want to look trim, not heavy. We want our faces to look symmetrical. No one wants their nose to look big or to appear with a double chin. We want to look like we have healthy, clear skin and well-groomed, shiny hair.

As photographers, we have it in our power to make substantial improvements in our subjects' appearances. You can't make a 300-pound woman look like she weighs 110 pounds, of course. However, by controlling the lighting, posing, and clothing a person wears, you can change their appearance enough to alter the outcome of the sale—and if you are going to go through the work of doing a session, you should at least get paid for it!

I start each session by analyzing my client. When doing this, I start at the top and work my way down, noting any features that should be emphasized or problem areas that should be minimized.

The Hair

When photographing a woman with long hair, I note which direction her hair flows. This give me insight to how I will pose her in relationship to the main light and also helps determine which side the main light will be on. I want the hair to have a place to flow and not need to be pulled back to avoid shadowing the face.

Width of the Face

I also look at the width of the face. This can vary substantially from person to person, but people generally want their face to be shown as an "average" width—not too wide (suggesting they are perhaps heavy) and not too narrow (which can look unhealthy). A wide face can be the result of excess weight, but some trim people also have rounder face shapes. Conversely,

some people who are overweight have perfectly average face shapes. Depending on what I see, I'll use some version of the lighting technique described in section 49.

The Ears

Ears are also a problem area for some people. If they are large or protrude (especially though the hair), try the approach laid out in section 50.

The Eyes

Next, I study the eyes. I look to see how they reflect the room lights. This gives me an idea of how well they reflect light. At this time, I also look at the eyes to see if there is a difference in their sizes. If I do notice a difference, I implement the technique discussed in section 50.

The Neck/Chin

Double chins are a problem for many adult men and women—even for those who are not overweight. To give your client a look they can live with, check out section 51.

The Nose

There is a big difference between having a larger nose that fits your face and having a nose that people notice. If you notice someone's nose immediately, you need to do something to reduce its apparent size. Otherwise, most people will have a problem with their final portraits. We'll look at how to make this correction in section 50.

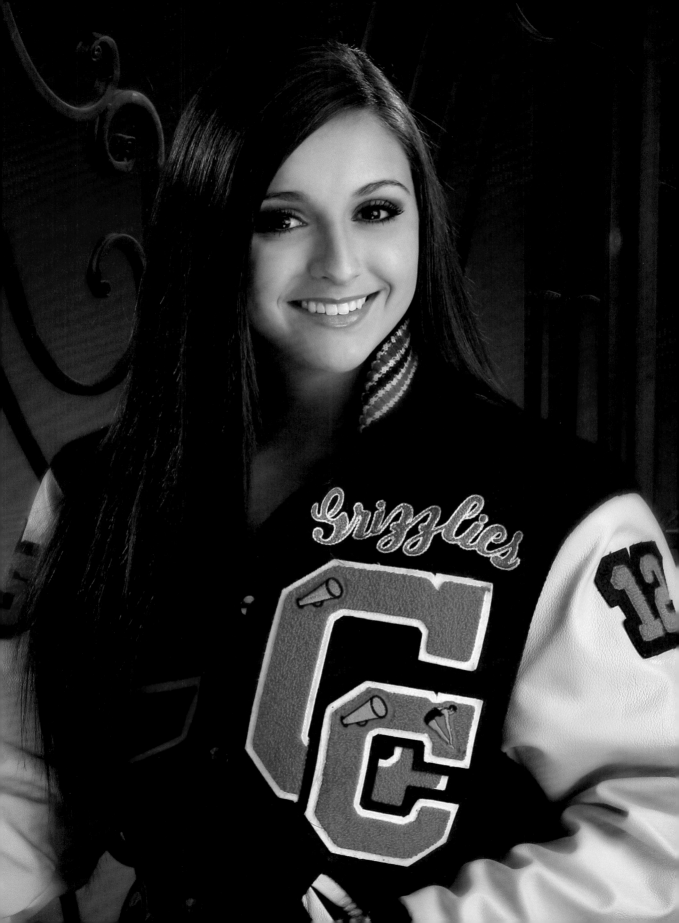

45 BROAD/SHORT LIGHTING

The shape of the subject's face will often suggest the best placement for the main light. There are two basic scenarios for using directional light, which is good for revealing the contours of the face. These are broad lighting and short lighting. (An option for non-directional lighting is covered in section 46.)

BROAD LIGHTING

To produce broad lighting, the subject's face is turned so that it is at an angle to the camera.

In broad lighting, the main light is placed on the side of the face that is more visible to the camera.

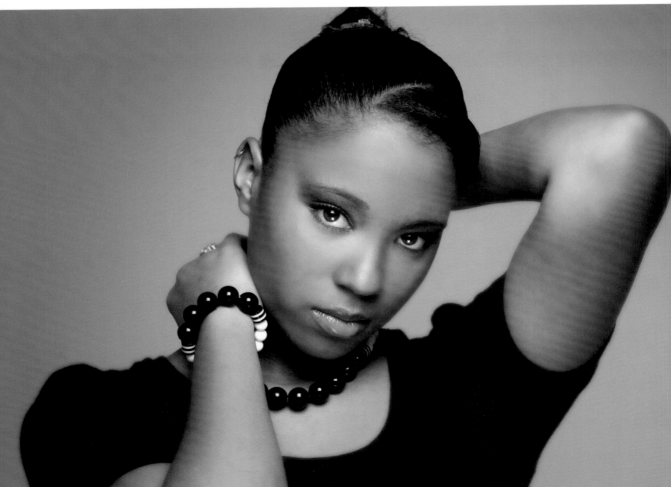

In short lighting, the main light is placed on the side of the face that is less visible to the camera.

The main light is then placed on the side of the subject's face that is more visible to the camera (the "broad" side of the face). Because this places highlights on a large part of the face, it's a good option for subjects with normal to narrow faces.

SHORT LIGHTING
To produce short lighting, the subject's face is turned so that it is at an angle to the camera. The main light is then placed on the side of the subject's face that is less visible to the camera (the "short" side of the face). Because this places highlights on a narrow part of the face, it's a good option for subjects with normal to wide faces.

OTHER CONSIDERATIONS
The physical shape of the subject's face is only one consideration, of course. Short lighting tends to be popular for all face shapes and sizes, since almost everyone appreciates a slimmer look. Creatively, you may opt for broad lighting to communicate a more open, friendly look. Short lighting, on the other hand, tends to create a look that is more dramatic.

Short lighting is a good lighting choice for a high percentage of my clients. Its slimming effect on the face is something most people appreciate.

Broad lighting creates an open, appealing impression of the subject. However, it tends to widen the look of the face, so it's best reserved for subjects with average to narrow face shapes.

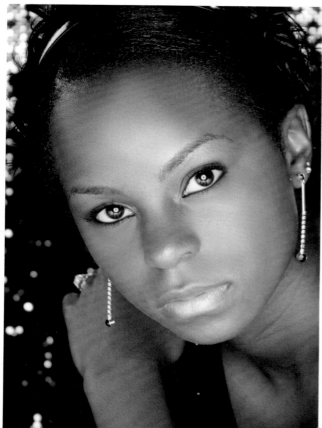

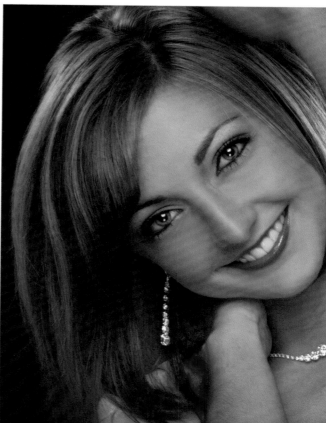

BUTTERFLY LIGHTING

Butterfly lighting (also known as Paramount lighting for its frequent use in early Hollywood portraiture) can really enhance the looks of certain individuals, bringing out the contours of the cheekbones, the impact and color of the eyes, and the luster on the lips. I also use butterfly lighting for small families in the studio—especially when photographing a younger, more stylish group of siblings.

SETUP

Traditionally, butterfly lighting has your main light over the camera and in front of the subject. A second light is then placed below the camera and in front of the subject. Since both lights are directly in front of the subject, this results in light that is relatively flat. The only shadowing is vertical, instead of horizontal as in the broad and short lighting scenarios discussed in the previous section.

Typically, I use a Halo or softbox as my main light above the camera, adding another softbox under the camera. When I use a rectangular softbox for the upper main light, I almost always work it in a horizontal position. This gives me a little more room to shoot through between the upper and lower lights, as well as more lighting width to cover groups and families.

I also like to use butterfly lighting with a strip light either above or below to alter the lighting characteristics—especially in boudoir and modeling sessions. To bring out more of the cheekbones, I sometimes switch the over-camera softbox to a parabolic, beauty dish, or even a grid spot. Each source produces different effects for the different shapes of my subjects' faces.

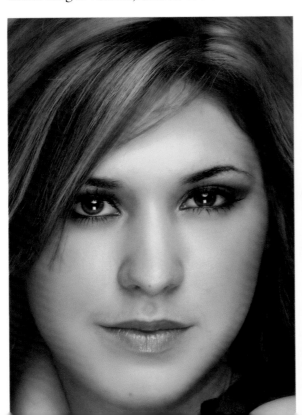

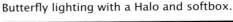
Butterfly lighting with a Halo and softbox.

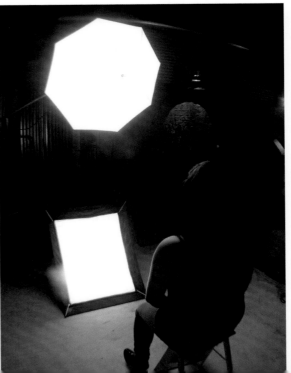

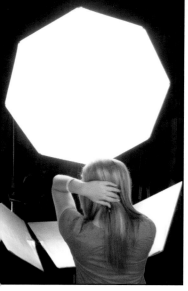

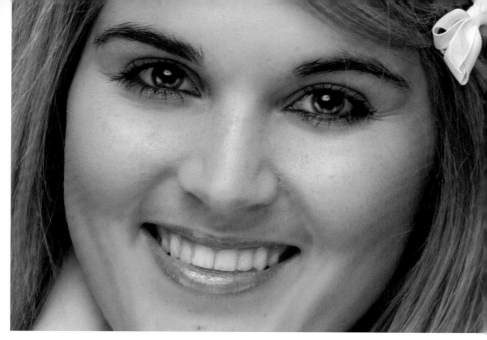

Butterfly lighting with a Halo and a trifold reflector.

Since it will be positioned directly over the camera, it is very helpful to put the upper light on a boom. If you put it on a light stand, you will constantly be shooting around the stand.

SUBJECT SELECTION

Since flat lighting like this requires posing the face directly at the camera (most of the time), butterfly lighting isn't a style of lighting for anyone whose face isn't quite symmetrical. Even the size of the subject's eyes needs to match—or at least not be noticeably different. This lighting style will make such imperfections very noticeable. Likewise, since *all* of the face will be lit, it's not a good choice for someone who feels their face looks too wide.

While clothing selection doesn't affect the lighting style from a technical point of view, your image will look more professional if the clothing and style of the portrait make sense together. If a young lady is doing senior portraits in a plain sweater, the "fashion" look of butterfly lighting won't make sense visually with her attire. A leather or jean jacket, a satin blouse, or an elegant dress all work well with this style of lighting—provided the end use of the portrait works with a fashionable look.

That brings me to another point. Not all styles of lighting are the best choice for all scenarios. Butterfly lighting would be perfect for a boudoir session, a fashionable senior shot, or stylish woman's portrait. However, if the woman were displaying a large portrait of herself in an elegant room of an elegant house, I would select a more traditional style of lighting. While there are no hard and fast rules, you have to use common sense when making these decisions—and make the selections that fit each client's end use, not just the style of lighting you happen to like the best.

Photography is my profession, not my hobby. I am not doing character studies. I am not a student who can waste time creating images that have no potential to sell.

FOR FURTHER STUDY

Butterfly lighting is a good choice for attractive subjects who want a stylish look in their images. It's a lighting style that is frequently seen in editorial photography, so it has immediate appeal for many fashion-savvy clients.

CORRECTIVE LIGHTING, PART 1

If lighting styles were each given a difficulty rating, corrective lighting would be at the black-belt level. "Corrective lighting" is a term I give to a lighting approach designed to deal with heavier clients, as well as a host of other appearance issues you may encounter with clients of all sizes.

WHAT OUR EGOS CAN HANDLE

For almost everyone, there is a separation between how we *really* look and how we see ourselves. In most cases, a straight-up depiction of reality is not what we want to see in our portraits—our egos just can't handle it.

Weight gain, the signs of aging, and even baldness happen slowly over time, so people often don't realize how much has changed until they come to you for a family portrait. Then Dad looks at the portraits and yells out, "Who is that bald, fat guy? I don't look like that!" Are they going to buy those portraits? Probably not.

How many business or family portraits have you taken in which the man has come in thinking his last sports jacket was going to fit, only to find out there is now 6 inches of stomach between the buttons and the holes?

Women do the same thing. Look at any woman trying on a dress. She will stand up straight, suck in her tummy, and push up her heels before she looks in the mirror. In the dressing room, it looks like things really haven't changed. She thinks to herself, "The girl still has it!" Then,

True professionals care about their clients—and about delivering images they'll love.

Targeted lighting lets you precisely control what viewers see in a portrait.

she is amazed when she sees her portraits and her stomach is so noticeable and her legs look heavy (wearing flats for comfort rather than heels to thin her legs!). Somehow, she expected that today's size 22 version of herself would photograph pretty much like the size 8 version of herself did at her wedding 20 years ago.

While this sounds like I am being mean, I'm not. I'm just pointing out the way our minds work. For years, I wondered how people could be so clueless about their own appearance. Now, I realize it's just how our minds work to save our egos from having to see things that we really don't want to see.

The importance of corrective techniques came together for me many years ago. It was just another session in my day booked with seniors. My last session was with a very sweet, shy young lady. She had a pretty face, although most people never really noticed it because she was substantially overweight. This was at a time when most high school girls were a size 2—not like today when *many* young ladies struggle with their weight.

As I started the session, I saw sadness in her eyes. I thought she was probably thinking of the comments that the other high-school kids would make when they saw her photographs. At that moment, I really started to care. I was 25 years old and pretty full of myself, but I thought to myself, "If I am really as good as I think I am and everyone tells me I am, I should be able to produce a beautiful portrait of this beautiful human being."

So, I went to work. I used her hair to soften the size of her shoulders. I used columns and trees/plants to hide the areas of her body that showed her size. I changed my lighting from a huge softbox to a small parabolic, covering it with white fabric for diffusion and adding barn

It doesn't matter how attractive you might think a person is—virtually everyone dislikes *something* about their appearance. It's your job to make sure they don't see whatever that is in their portraits.

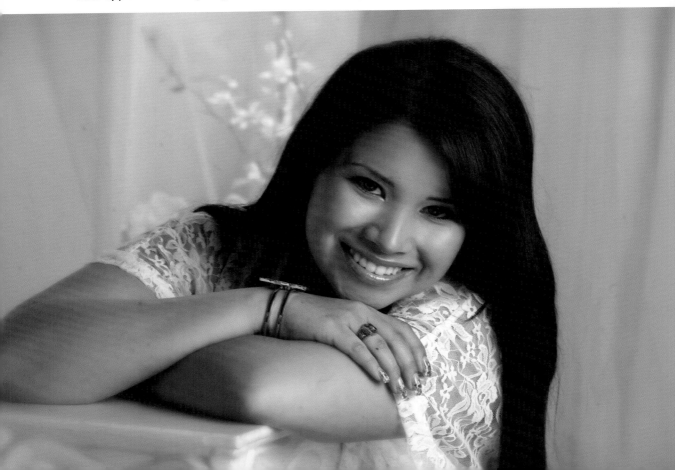

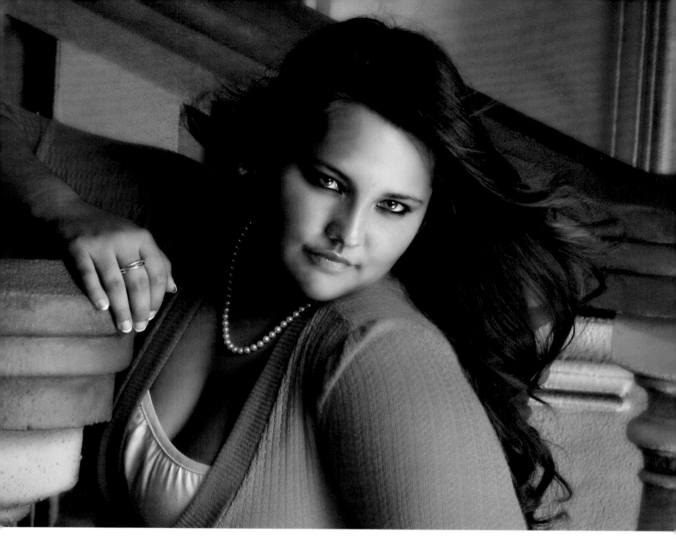

doors so I could light only what I wanted the viewer to see. I used pinpoint lighting to draw the viewer's eye to that beautiful face and left in shadow any areas that would have distracted the viewer from that beauty.

I worked harder in that session than I had in all of the day's previous sessions combined. But when I was done, I felt something I never had before: I felt what it was like to be a true professional. It was the first time in my professional career that I cared enough about a client to really put myself in her shoes and feel what she was going to feel. Although I wasn't a master

at that point, it ignited in me a desire to go beyond what the average photographer could do.

Two weeks later, the proofs came in and I was in the studio when the mother and the senior picked them up. The mother had tears in her eyes as she walked toward me and gave me a hug. She said, "I always tell my daughter she is beautiful, and you have captured the beautiful girl I see."

Even today, I get choked up when I share that story at a workshop or seminar. We have the talent to change the way a person looks at themselves, we just have to choose to use it.

Up until the session I described in the previous section, I (like most young photographers) practiced on models—perfect "hard bodies" that I impressed myself by making look perfect. In retrospect, I realize that didn't really reflect some profound skill on my part; the camera was simply recording reality. Let's face it, some women are so beautiful that we as photog-

Controlling the lighting lets you precisely sculpt your client's appearance.

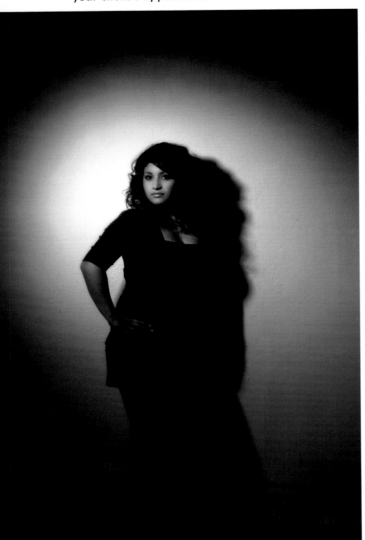

raphers really don't have to do much to make them look amazing—they'd look great in an iPhone snapshot! Those perfect people are the subjects most of us practice on and get excited about photographing. But how can we learn to photograph our clients, who are far from perfect, if we only practice on perfect people?

From that point on, when I set up test sessions or wanted to practice new lighting techniques, I selected people who looked just like my clients. I wanted to see how much I could improve their looks, how much thinner I could make them look. This session changed me as a photographer and is the reason I am still enjoying photography today.

FUNDAMENTAL TECHNIQUE

Corrective lighting is more about working with shadow than light, so low-key backdrops should generally be employed. Additionally, you want to work in a totally dark studio. It's best if all the walls, ceiling, floor, and other surfaces around the subject are black. This helps to avoid having light bounce around the set and end up in places where you don't want it.

Next, you'll add small, controllable lights—both as your main light source and for accent or hair lights. You place your lighting precisely and *only* where you want the viewer's eye to see the subject. Even in full-length photos, the main light should remain small, focusing the most intense light on the face and letting the body fall into subdued light or shadow. All accent lights

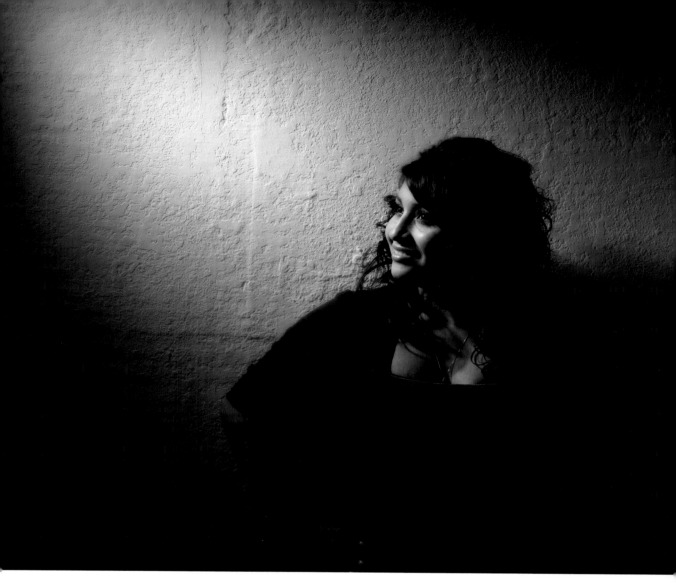

must be fitted with barn doors to direct light only to the area you want to separate or draw attention to.

This results in an amount of shadowing that is higher than in traditional lighting, in which you often fill the shadow of the entire subject with a large reflector or flash. With corrective lighting, you only fill the shadows that you have to. This means any fill will primarily be on the face (although heavy shadows on the side of the face often help reduce the apparent size).

A Worthwhile Effort

This may seem like a lot of work, but isn't this why we are professionals? Shouldn't we be able to take great portraits of *all* our clients, not just the ones who are already exceptionally gorgeous? When someone comes to you for a portrait, are you going to take their money, knowing that your limited skills (or disinterest) means they won't be happy with the results?

Now that we've covered the basic approach for corrective lighting, let's move ahead to look at how we can use this approach (especially in combination with careful posing) to hide many problems. We'll start at the top and work our way down the body.

THE EYES

You may notice that the catchlight in one eye is stronger than the catchlight in the other eye. This happens when one eye is smaller or one eyelid is lower. If you don't correct this in your lighting it will be obvious in any head-and-shoulders portrait. A quick fix is to put the main light on the side of the smaller eye. Lower the main light a little more than normal to ensure a large catchlight in the smaller eye. The larger eye on the shadow side of the frame will have a slightly less noticeable catchlight, thereby balancing the eyes in relative size (at least to the camera). Clients won't purchase portraits in which their eyes look uneven.

THE EARS

If I see larger or protruding ears, I select a main light source with heavier shadowing. I then turn the face toward the main light source to hide one ear on the far side of the head. I minimize

Balanced catchlights are required to make the eyes look even and attractive.

A change in pose and lighting reduces the visibility of the ears.

the visibility of the other ear through the use of shadow and reduced separation between the background and the ear.

THE NOSE

The appearance of size in a nose is increased or reduced by the shadows around the nose. If I see someone with a large nose, I opt for a flatter main light source. I often choose a softbox and position it closer to the camera (as opposed to at the 90 degree position). I might also select a frontal lighting, like butterfly lighting, and increase the fill from below the subject to reduce the shadow that appears under the nose.

Minimizing the shadowing reduces the visibility of the nose.

THE CHIN

A double chin has several possible fixes, none of which involve lighting (although keeping light off the chin area will help). One option is to select a higher camera angle and have the subject raise their chin slightly. Alternately, you might have the subject lightly rest their chin on their hand, blocking the double chin from view. Another choice is to have the subject lean their shoulder and head forward in a seated or standing pose. This will stretch out the neck area. The final (and most effective) strategy is to use the "turkey neck" pose. Have the subject extend their chin outward toward the camera and then bring their entire face downward to hide the double chin. This works well for adult men in collared shirts and ties, outfits that make most adult men (other than *very* thin ones) look like they have a double chin.

THE NECK

The neck is the next area down and one that can be quite unattractive. The first signs of age and weight gain often show in the neck. If the neck is unattractive because of age, I simply select clothing or a pose to hide this area. You can effectively do the same thing for a large neck.

However, sometimes the neck *needs* to show for the type of portrait that you're taking. Someone posing for a business portrait, for example, will look odd in a turtleneck or with their chin resting on their hands. If this area is a problem and I must show it, I use a main light source that produces a good shadowing and place it close to 90 degrees from the subject. I then turn the body away from the main light and turn the face back toward the main light. The pose pulls the skin of the neck more taut, and the shadowing helps to de-emphasize the area.

Stretching the chin forward, as seen below, effectively reduces the appearance of a double chin and is not obvious from the camera position. Resting the chin on the arm or the hand, as seen on the facing page, is a quick way to conceal the neck/chin area in casual portraits.

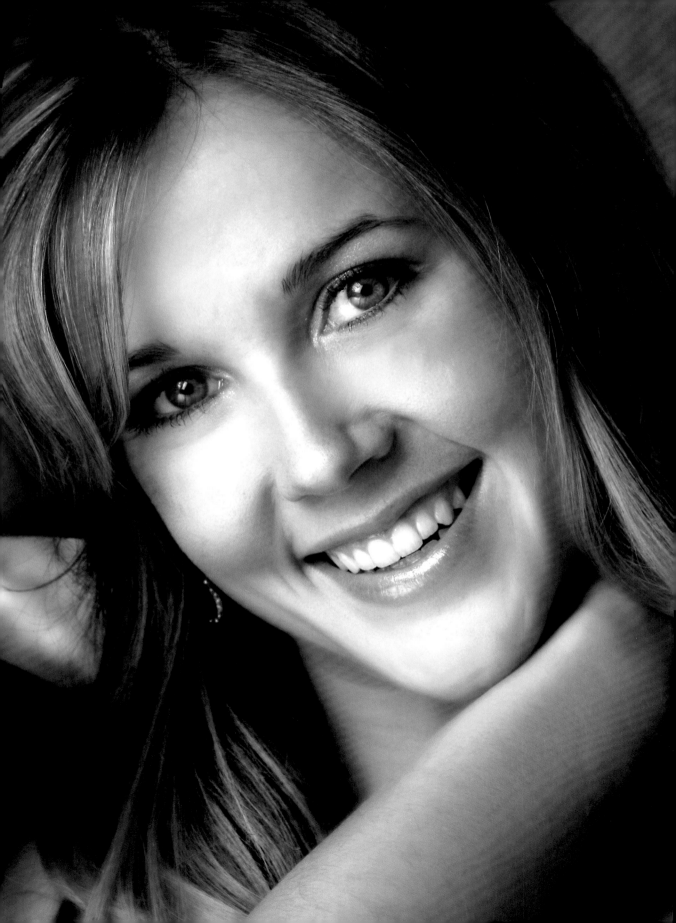

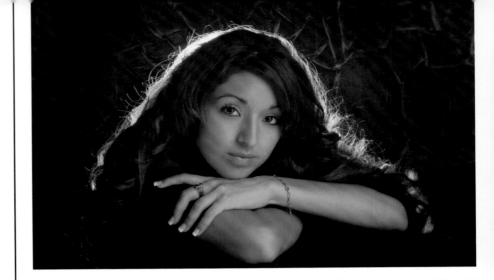

▼ FOR FURTHER STUDY

There are countless combinations of lighting and posing that will help to disguise the neck and chin area—a problem spot for many of our portrait subjects.

CLOTHING SELECTION

You would think that if someone showed up at a session with bare shoulders and arms, they must not have a problem with the size of those areas of their body. Otherwise, they would cover them up, right? Wrong! I photograph women every day who have large shoulders and heavy arms— yet they want to wear a halter or summery dress. Some women with larger shoulders want to wear off-the-shoulder fashions and simply trust that you will somehow reduce the size of their shoulders to a point where they will be able to live with the images.

Arms and shoulders should be covered if size is at all an issue. Preparing your client for their session is the best way to handle such problems. Whether you prepare a DVD or have a staff member explain the best clothing choices, your clients have to know what is best to wear for the types of images they are taking. Don't put it in a brochure, because most people won't read it.

LIGHTING AND POSING

If the client's arms are visible, I make sure the arms are posed away from the body; putting any pressure on them will only make them look larg-

Long sleeves look good on everyone and hide areas many clients are concerned about.

For a much improved image (above), I turned the subject's body away from the main light, then turned her face back toward it. Having her lift her shoulder to her chin completed a flattering look.

er. I also choose a main light with barn doors so I can reduce the light falling on the problem area. If that doesn't darken the arms enough, the black side of a small reflector can be positioned to hold more light back and further darken the shoulders/arms.

For portraits of women, a good way to reduce the size of the shoulder is to pose the body toward the shadow side of the frame, turning the face back toward the main light. I then have the client lift the shoulder closer to the camera up toward her chin. This makes an amazing difference in the look of the shoulders.

The bustline of a woman is very important to the look of the final portrait. In today's augmented society, too much can be more of a problem than too little—but you have to know how to deal with both.

EVALUATE THE CLIENT AND THE END USE

Most men think it is impossible to have too much cleavage or for a woman to look too shapely, but in business and politics, women have a hard time being taken seriously if the first thing you notice in their portrait is the size of their breasts.

As you look at a woman's bust (not too long, guys, unless you want to creep her out) you have to decide what is appropriate for the woman and the type of portrait she is having done. If a woman comes in to shoot photographs for a boyfriend or husband and brings a lot of low-cut tops, you can safely guess that she wants to emphasize that area of her body.

If that busty client with low-cut tops was, on the other hand, coming in to shoot portraits for her career as a real estate agent, you'd know to select lighting and/or poses that don't call so much attention to this area of her body.

SUBDUE OR ENHANCE?

The size of the breasts is basically established by the shadows in the cleavage area. Enlarge the

Notice how the different shadowing affects the appearance of the bust in these boudoir images.

shadow in the cleavage area and you enlarge the apparent size; reduce the shadowing and you reduce the apparent size.

For boudoir or more fashion-oriented portrait styles, where enlarging the shadow in the cleavage area is usually desirable, I would select a harder light source—like a beauty dish with barn doors. This will provide enough shadowing to increase the appearance of size.

If the emphasis on the bust area needs to be reduced (as it would be for a business portrait), I would select a softer source of light and pose the subject's body so it is facing toward the main light source. This will minimize the shadowing in the cleavage.

Turn the subject away from the main light to increase the shadows that enhance the shape of the bust.

ALWAYS EVEN

Another problem that some women have in this area is that their breasts are not equal in size. Women who have this problem tend to find it embarrassing, so you need to use clothing selection, posing, and lighting to address the issue.

Dark, loose clothing can help. Another approach is to lower the camera angle and hide the smaller breast behind the larger breast that is closer to the camera. To further hide the inconsistent size, increase the shadow in this area. Shadow is truly our friend!

For boudoir sessions, great cleavage is something most women are looking to show off.

▼ FOR FURTHER STUDY

In boudoir and fashion-oriented photography, most women want to see their cleavage enhanced. By using side lighting to create shadows in the cleavage area, you can make this happen.

The waistline will be an issue for most of your clients—even the very trim ones. Happily, there are some simple fixes for waistline problems.

SLIMMING THE ALREADY SLIM

Average-sized people, those with fairly flat stomachs, still want their waistlines to appear as small or smaller than they really are. When this is a concern, I use a harder light source with good shadowing (a beauty dish, a Halo moved more to the 90 degree position, or a strip light).

I then pose the subject with their body facing toward the shadow side of the frame and turn the face back toward the light. Then, I add fill only to the shadow on the face, letting the waistline go into shadow. You can see before-and-after examples of this below.

SLIMMING THE NOT-SO-SLIM

When someone has such a large stomach (one that protrudes when you turn them to the side), you need to deal with the larger waistline by pairing very dark clothing with controllable lighting that yields heavy shadowing. Barn doors are great for this—or you can use a very small main light to illuminate only the face and let everything below the shoulders remain in shadow.

WATCH THE SEPARATION

The placement of the background light is also important for the waistline. The background

Women always want their waistlines to appear as thin as possible. For an average subject, switching from a straight-on pose (left) to a pose with the body turned (right) helps to slim the waist.

Use separation light to accent only the parts of the client you want to draw attention to. Three variations are shown here, with separation light on the lower body (left), torso (center), and head and shoulders (right).

light (on a low key background) will usually be placed to create a hot spot, which draws the eye to an area of separation.

For the average person, this is fine. For subjects who are concerned about their waist (or hips/thighs), careful placement of the background light becomes critical. You have to decide what parts of the body you will separate from the background and what parts you will let blend into the background. Many times, even in a full-length pose, I will have the background light separate only the head and the tops of the shoulders, allowing the rest of the body to almost merge with the background. Then, accent lights are added to gently separate the parts of the body that won't add to the appearance of weight.

Leaving space between the arms and the waist helps both body parts look slimmer.

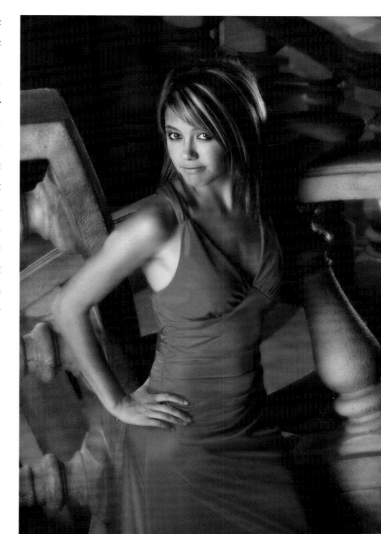

▼

FOR
FURTHER
STUDY

When creating mater-
nity portraits, your
objective for capturing
the midsection is quite
different. To show the
mother-to-be's preg-
nant form, you'll want
to position her at an
angle to the camera
and use shadow (cre-
ated by directional
lighting, as seen here)
to emphasize the
roundness of her belly.

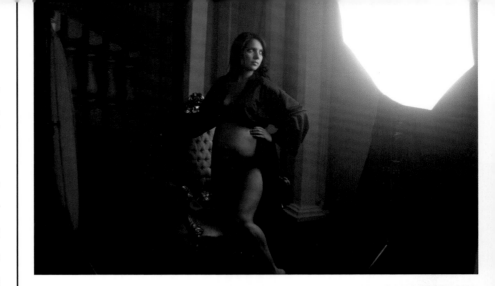

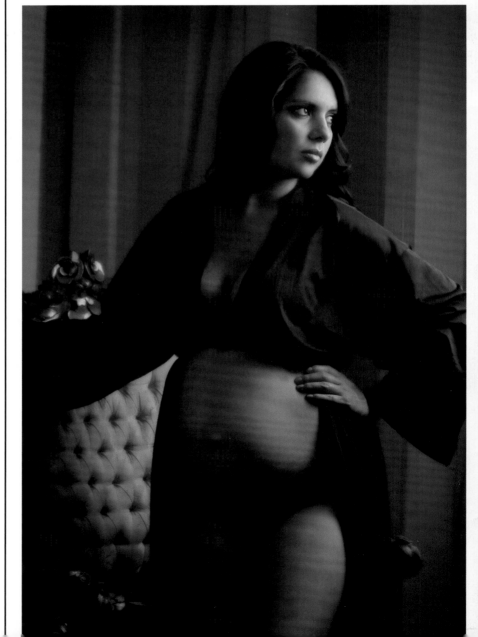

144

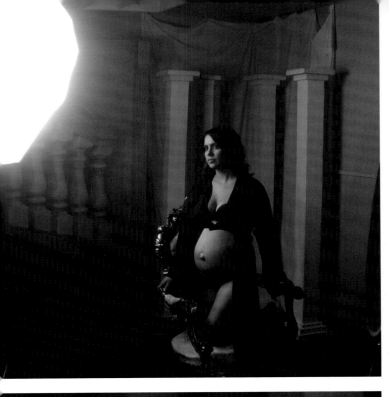

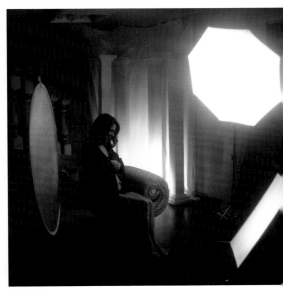

HIPS, THIGHS, AND FEET

Legs are one of those areas of the body that either look great or don't. Luckily, if a woman has beautiful legs, she will want to show them; if she doesn't, you will typically see it in her clothing selection. However, there are also those women who live in denial. When this is the case, it's time for some tough but tactful love—

and a clever combination of lighting and posing. (Aside from the need to design an attractive pose, this area isn't of nearly as much concern when photographing men as when photographing women. For posing tips, see my book *Step-by-Step Posing for Portrait Photography*, also from Amherst Media®.)

SLIM SUBJECTS

There are a few scenarios here. If the client is thin, you will want to make these areas visible and shapely in portraits created for personal use. You can use a larger light source to illuminate this area or use accent lights to draw attention to the

DON'T SHOW IT ► If there is a reason not to show a particular area of the body, you shouldn't. If a woman has major cellulite and a super-short miniskirt, it's your job to at least try to direct her away from doing full-length poses. This applies to any part of the body that will reduce your chance of a sale—large arms with sleeveless tops, too much cleavage showing for the type of portrait being taken, or anything else that the client will not want to see in her portrait. The trick is explaining the concern in a way that informs her without embarrassing her. To do this, it helps to talk about women in general (not *her* specifically). For example, if you notice that a client has large arms and sleeveless tops, you might say, "Many women worry about the size of their arms or how toned they look. I see you have some sleeveless tops—do you want to try one or just skip them?" This uses other women's concerns as a bit of advice for the current client—without embarrassing her or implying *she* has large arms!

Notice how the shadowing reveals that the subject's legs are well toned.

hips and thighs. Your goal should be to show the length, slimness, and muscular contours of the legs. If a woman has come to you for a business image, of course, this area should not be posed or lit in such a way as to create a sense of allure.

Heavier Subjects

If your client is a larger woman, she will probably be especially concerned about this area of her body looking large. If full-length portraits are required, select darker clothing and pose the subject against a darker background. Select a smaller, controllable main light with good shadowing to minimize the light on the lower body and allow

this area to blend into the shadows. You'll also want to avoid creating separation between the subject's lower body and the background; this will only outline the problem area.

FEET

Clients don't want their feet to appear large or their toes to look long. Also to be avoided are funky colors of toenail polish, long toe nails (especially on the guys), or (generally) poses where the bottom of the feet show. If the bottom of the feet are to show, make sure they are clean. One way to minimize the emphasis on the feet is to simply let them fall into shadow.

The principles and strategies I have outlined for lighting single subjects also apply when you are working with multiple subjects. I have seen many photographers do an excellent job lighting a single subject, then come up with some of the strangest lighting I have ever seen when they are working with families or other groups. Some photographers have told me they use two main lights, both placed at a 45 degree angle to the group. This is the same lighting setup that photographers use to copy documents placed on a copy stand and, not surprisingly, the lighting is flat and even, without shadow. Doing this would provide subjects with a copy of their faces—a virtual road map of the group. Who would pay for something like that?

The Basic Concepts Remain

Your basic lighting concept doesn't change as you add people. You still have a single main light source, you still have a fill source, and you still have hair, accent, and background lights. There are a few changes you will need to make as the number of people in the group increases, but the basic concepts are the same.

Size of the Main Light

The first obvious change is in the size of the main light source. As you add people to a group, the space their bodies takes up increases. To get lighting across that space, the main light must be positioned farther from the subjects so it doesn't appear in the shot. To maintain the lighting characteristics you would have with the light in closer, you need to use a larger modifier. (Remember, the farther the light is placed away from the subject, the harder/more contrasty the light becomes, so a larger light source placed farther away will produce a similar light characteristic as a small light source that is placed closer to the subject, with all other things being equal.)

Fill Light

Another difference in photographing a group (as opposed to a single person) is the fill. I still use reflected fill if I am photographing three or four people closer up. The minute I change to full-length posing for a group, I use a flash (not reflectors) for fill. There are a few reasons why. First of all, if you are photographing a large number of people, a reflector won't get into the nooks and crannies that exist between people. Also, if you have subjects posed in rows, a reflector won't throw light onto the people placed behind the front row. Finally, the smaller the facial size, the less precision is needed in your lighting.

ACCENT LIGHTS

When photographing multiple subjects, hair lights and background lights are used in the same fashion as with a single person. Before turning on a hair light, always check to see if anyone in the group has very thin hair. If you can see an individual's scalp through their hair, try to pose that person so that the hair light does not strike them. If that's not possible, at least position them as far as possible from the hair light. If the light poses a problem, turn off the hair light and increase the background light to create better separation. The same techniques apply to bald men; keep the light off of the man's head to avoid creating a distracting shine.

Accent lights can be used if the shadow side of the frame needs added separation or basically needs to be brightened up. Trying to use accent lights on both sides of the camera as if you were photographing a single subject against a dark background only works if you can position the ladies at the outer edges of the grouping and, even then, only the side of the hair that faces away from the group is highlighted. Therefore, I don't typically use many accent lights unless there is a dark area that I need to brighten.

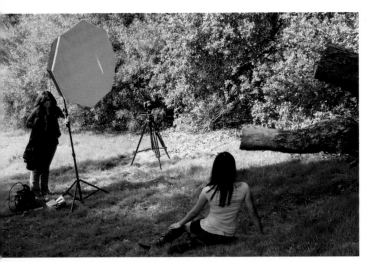

Studio lighting has many applications outdoors and at other non-studio locations, where it can transform unusable (or just lackluster) lighting scenarios into great portrait settings.

TRIAL AND ERROR

Outdoors, using flash is a bit of a guessing game. You might meter, look at the image on your LCD or laptop, and check the tonal distribution on a histogram, but the exact lighting effect—and how a lighting ratio looks on your client's particular skin tones—will never be completely known until you pull the image up on the computer back at the studio. This is one reason I tend to use flash outdoors only with large families or in more scenic individual shots. In both cases, the facial size is smaller and any slight problems in your lighting ratios won't be as noticeable.

LIGHTING RATIOS

When using studio light outdoors, you'll end up with lower lighting ratios than you would in the studio, but you still need to be sure that your light adds enough shadow to create depth and the sense of a third dimension in the final images. I usually start out with a 3:1 lighting ratio (my main light meters 1.5 stops greater than my fill light) for subjects with light to medium skin tones and wearing neutral colors. If I were photographing a group of subjects with darker skin tones and/or the individuals were wearing darker clothing, I would turn up the fill and start to meter just 1 stop less than the main light.

CONCLUSION

When I learned photography, most students of photography turned to professors, successful professional photographers, or books written by working professionals. Today, that's not always the case. More and more, those seeking to learn are inadvertently being led astray by unqualified "teachers." I don't believe you can learn to be great from mentors who are not.

WHERE DO YOU WANT TO BE?

I never realized how vital this was until I went to the park one Sunday afternoon. There were numerous people there taking photographs, and I had nothing better to do than watch these "photographers" work. Most of them, however, weren't photographing clients or practicing—they were showing *other* photographers how they take photos. Unfortunately, these "teaching photographers" should not have been showing *anyone* how to do *anything*. One standout was an older man who was advising three younger photographers to use the noon-time sun as a main light source! (Can you say raccoon eyes?)

The same is true for videos on YouTube. Just because someone can make an "instructional" video and put it on YouTube, doesn't mean they should. I have seen many student photographers making videos to help other students.

Everyone has to learn and start somewhere, but you're on a path to nowhere if you're learn-

ing from people who don't know what they are doing (or know only slightly more than you). You should never take advice from anyone who isn't where you want to be. If you only want to be slightly better than you are now, learn from those people. If you want to be a professional photographer and make a great income in photography, learn from photographers who are doing just that.

Each school year, we hire a few photographers to help with dances and school events, as well as to assist in the studio. I interview many photographers—some know nothing, some have acquired bad habits through learning from other students, and a few are well-trained photographers. Honestly, I prefer to hire the person who knows nothing and train them properly, than to

hire someone who has learned bad habits and practiced how to be a bad photographer. Undoing their bad habits is very difficult.

INVEST AND COMMIT

No matter where you are in your study of photography, we have all been there before. It's not easy learning to be a professional photographer, but it is much easier than *not* learning and trying to fake it. Learn and practice, then learn and practice some more. Mastering the skills necessary to be a professional photographer will take years, not months or weeks, but once you get through it all—whether in school or self-study— you will have the skills that people will pay handsomely for. If you take the time to truly learn your craft, you will command the respect that

comes from providing a professional service at a professional price.

Don't Charge Too Soon

When I first starting studying photography at the age of 17, an older gentleman at the local camera store told me that, as I continued to improve my shooting skills, I should practice on family members or cute girls in high school and would-be models. He advised me, for the moment, to give away my work because it wasn't yet of a professional quality.

However, once my work improved to a professional level, he said that I should charge a professional price when working with clients but give my work away when practicing or doing test sessions. He was absolutely right. Any other ap-

proach reduces the value of the product we sell—and that's something we then have to live with throughout our professional lives.

Some younger photographers talk about undercutting working professionals and are almost proud of it. Eventually, however, these younger photographers will turn pro and find themselves in the shoes of the folks they wanted to put out of business. By undercutting, they are ensuring a future for themselves that lacks stability and the ability to earn a decent living.

Moving Forward

Before I leave this profession, I want to see it in a better condition than when I started—and that starts with you. I have left a mark on the field, but many of you reading this book haven't even started yet. You are the future and whether photographers are looked at with respect or as a bunch of unprofessional camera owners willing to work for nothing depends on *you!* Learn, practice, and get better.

The reality is that the average consumer now puts less value on professional photography than they did even five years ago. This is a livelihood that endured the Great Depression—but now we're going to let the sheer number of digital camera owners willing to take photos for next to nothing reduce the value of our entire profession? No way.

At the moment, there are still clients who value truly professional photography and are willing to pay professional prices. However, the current trends in photography will have to change if this is to remain a viable profession for those younger photographers who want to make a decent living doing what they love in the decades ahead.

It is up to all of us who have taken the time to learn professional photography to help those younger photographers coming up. We need to direct them, to help them master their craft before they try to sell their skills. We need to help them develop into the kind of photographers that take this profession to new heights instead of lowering the value that the average person puts on what we create. If you are an established photographer who blames the decrease in your profits on all those "newbies," let me ask you: what have you done to put them on the right path? What have you done to teach them the correct way of running a photography business and entering this profession properly?

Photographers have guarded the "secrets" of their success for too long—and that's part of what has led us to this point. Ask any younger photographers why they go to YouTube and photo-group meetings, trying to learn more, and many will tell you that they have tried to talk with professional photographers in their area—but no one would give them the time of day! Education is the key. If you're a working pro, I urge you to mentor young photographers and help them develop into the kind of photographers who elevate this profession. Yes, you may help some young photographers turn into honest competition—but it will be competition that is charging professional prices for a professional product, not snapshots for $50 on a DVD!

That said, should you have questions about this book or the information in it, you can contact me at jeff@jeffsmithphoto.com. Please don't call the studio. Again, I'm a working pro—so if I'm there, I'm photographing sessions.

INDEX

OTHER BOOKS FROM
Amherst Media®

DON GIANNATTI'S Guide to Professional Photography

Perfect your portfolio and get work in the fashion, food, beauty, or editorial markets. Contains insights and images from top pros. *$39.95 list, 7.5x10, 160p, 220 color images, order no. 1971.*

Lighting Essentials: LIGHTING FOR TEXTURE, CONTRAST, AND DIMENSION

Don Giannatti explores lighting to define shape, conceal or emphasize texture, and enhance the feeling of a third dimension. *$34.95 list, 7.5x10, 160p, 220 color images, order no. 1961.*

Just One Flash

Rod and Robin Deutschmann show you how to get back to the basics and create striking photos with just one flash. *$34.95 list, 8.5x11, 128p, 180 color images, 30 diagrams, index, order no. 1929.*

TUCCI AND USMANI'S The Business of Photography

Take your business from flat to fantastic using the foundational business and marketing strategies detailed in this book. *$34.95 list, 8.5x11, 128p, 180 color images, index, order no. 1919.*

WES KRONINGER'S Lighting Design Techniques
FOR DIGITAL PHOTOGRAPHERS

Create setups that blur the lines between fashion, editorial, and classic portraits. *$34.95 list, 8.5x11, 128p, 80 color images, 60 diagrams, index, order no. 1930.*

CHRISTOPHER GREY'S Advanced Lighting Techniques

Learn how to create stylized lighting effects that other studios can't touch with this witty, informative guide. *$34.95 list, 8.5x11, 128p, 200 color images, 26 diagrams, index, order no. 1920.*

DOUG BOX'S Flash Photography

Doug Box helps you master the use of flash to create perfect portrait, wedding, and event shots anywhere. *$34.95 list, 8.5x11, 128p, 345 color images, index, order no. 1931.*

500 Poses for Photographing High School Seniors

Michelle Perkins presents head-and-shoulders, three-quarter, and full-length poses tailored to seniors' eclectic tastes. *$34.95 list, 8.5x11, 128p, 500 color images, order no. 1957.*

500 Poses for Photographing Men

Michelle Perkins showcases an array of head-and-shoulders, three-quarter, full-length, and seated and standing poses. *$34.95 list, 8.5x11, 128p, 500 color images, order no. 1934.*

LED Lighting: PROFESSIONAL TECHNIQUES
FOR DIGITAL PHOTOGRAPHERS

Kirk Tuck's comprehensive look at LED lighting reveals the ins-and-outs of the technology and shows how to put it to great use. *$34.95 list, 7.5x10, 160p, 380 color images, order no. 1958.*

Off-Camera Flash
TECHNIQUES FOR DIGITAL PHOTOGRAPHERS

Neil van Niekerk shows you how to set your camera, choose the right settings, and position your flash for exceptional results. *$34.95 list, 8.5x11, 128p, 235 color images, index, order no. 1935.*

Nikon® Speedlight® Handbook

Stephanie Zettl gets down and dirty with this dynamic lighting system, showing you how to maximize your results in the studio or on location. *$34.95 list, 7.5x10, 160p, 300 color images, order no. 1959.*

THE DIGITAL PHOTOGRAPHER'S GUIDE TO
Light Modifiers SCULPTING WITH LIGHT™

Allison Earnest shows you how to use an array of light modifiers to enhance your studio and location images. *$34.95 list, 8.5x11, 128p, 190 color images, 30 diagrams, index, order no. 1921.*

DOUG BOX'S
Available Light Photography

Popular photo-educator Doug Box shows you how to capture (and refine) the simple beauty of available light—indoors and out. *$39.95 list, 7.5x10, 160p, 240 color images, order no. 1964.*

Understanding and Controlling Strobe Lighting

John Siskin shows you how to use and modify a single strobe, balance lights, perfect exposure, and more. *$34.95 list, 8.5x11, 128p, 150 color images, 20 diagrams, index, order no. 1927.*

THE BEST OF **Senior Portrait Photography,** SECOND EDITION

Rangefinder editor Bill Hurter takes you behind the scenes with top pros, revealing the techniques that make their images shine. *$39.95 list, 7.5x10, 160p, 200 color images, order no. 1966.*

Flash Techniques for Location Portraiture

Alyn Stafford takes flash on the road, showing you how to achieve big results with these small systems. *$34.95 list, 7.5x10, 160p, 220 color images, order no. 1963.*

Master Posing Guide for Portrait Photographers, 2nd Ed.

JD Wacker's must-have posing book has been fully updated. You'll learn fail-safe techniques for posing men, women, kids, and groups. *$39.95 list, 7.5x10, 160p, 220 color images, order no. 1972.*

Christopher Grey's **Posing, Composition, and Cropping**

Make optimal image design choices to produce photographs that flatter your subjects and meet clients' needs. *$39.95 list, 7.5x10, 160p, 330 color images, index, order no. 1969.*

Also by Jeff Smith . . .

Step-by-Step Posing for Portrait Photography

Jeff Smith provides easy-to-digest, heavily illustrated posing lessons designed to speed learning and maximize success. *$34.95 list, 7.5x10, 160p, 300 color images, order no. 1960.*

JEFF SMITH'S GUIDE TO
Head and Shoulders Portrait Photography

Make head and shoulders portraits a more creative and lucrative part of your business. *$34.95 list, 8.5x11, 128p, 200 color images, index, order no. 1886.*

JEFF SMITH'S **Senior Portrait Photography Handbook**

Improve your images and profitability through better design, market analysis, and business practices. *$34.95 list, 8.5x11, 128p, 170 color images, index, order no. 1896.*

Corrective Lighting, Posing & Retouching FOR DIGITAL PORTRAIT PHOTOGRAPHERS, 3RD ED.

Jeff Smith shows you how to address and resolve your subject's perceived flaws. *$34.95 list, 8.5x11, 128p, 180 color images, index, order no. 1916.*

JEFF SMITH'S
Studio Flash Photography

This common-sense approach to strobe lighting shows photographers how to tailor their setups to each individual subject. *$34.95 list, 8.5x11, 128p, 150 color images, index, order no. 1928.*

Posing for Portrait Photography
A HEAD-TO-TOE GUIDE FOR DIGITAL PHOTOGRAPHERS, 2ND ED.

Jeff Smith shows you how to correct common figure flaws and create natural-looking poses. *$34.95 list, 8.5x11, 128p, 200 color images, index, order no. 1944.*

75 Portraits
by Hernan Rodriquez

Conceptualize and create stunning shots of men, women, and kids with the high-caliber techniques in this book. *$39.95 list, 7.5x10, 160p, 150 color images, 75 diagrams, index, order no. 1970.*

Location Lighting

Stephanie Zettl shows wedding and portrait photographers how to create elegant, evocative, and expressive lighting for subjects in any location. *$39.95 list, 7.5x10, 160p, 200 color images, 5 diagrams, order no. 1990.*

Direction & Quality of Light

Neil Van Niekerk shows you how consciously controlling the direction and quality of light in your portraits can take your work to a whole new level. *$39.95 list, 7.5x10, 160p, 195 color images, order no. 1982.*

On-Camera Flash TECHNIQUES FOR
DIGITAL WEDDING AND PORTRAIT PHOTOGRAPHY

Neil van Niekerk teaches you how to use on-camera flash to create flattering portrait lighting anywhere. *$34.95 list, 8.5x11, 128p, 190 color images, index, order no. 1888.*

THE ART AND BUSINESS OF HIGH SCHOOL
Senior Portrait Photography,
SECOND EDITION

Ellie Vayo provides critical marketing and business tips for all senior portrait photographers. *$39.95 list, 7.5x10, 160p, 200 color images, order no. 1983.*

Backdrops and Backgrounds
A PORTRAIT PHOTOGRAPHER'S GUIDE

Ryan Klos' book shows you how to select, light, and modify man-made and natural backdrops to create standout portraits. *$39.95 list, 7.5x10, 160p, 220 color images, order no. 1976.*

BILL HURTER'S
Small Flash Photography

Learn to select and place small flash units, choose proper flash settings and communication, and more. *$34.95 list, 8.5x11, 128p, 180 color photos and diagrams, index, order no. 1936.*

Studio Lighting Anywhere

Joe Farace teaches you how to overcome lighting challenges and ensure beautiful results on location and in small spaces. *$34.95 list, 8.5x11, 128p, 200 color photos and diagrams, index, order no. 1940.*

Hollywood Lighting

Lou Szoke teaches you how to use hot lights to create timeless Hollywood-style portraits that rival the masterworks of the 1930s and '40s. *$34.95 list, 7.5x10, 160p, 148 color images, 130 diagrams, index, order no. 1956.*

Family Photography

Christie Mumm shows you how to build a business based on client relationships and capture life-cycle milestones, from births, to senior portraits, to weddings. *$34.95 list, 8.5x11, 128p, 220 color images, index, order no. 1941.*